IMAGES
of America

WASHINGTON HEIGHTS,
INWOOD, AND MARBLE HILL

On the cover: Please see page 69. (Author's collection.)

IMAGES
of America

WASHINGTON HEIGHTS, INWOOD, AND MARBLE HILL

James Renner

ARCADIA
PUBLISHING

Published by Arcadia Publishing
Charleston SC, Chicago IL, Portsmouth NH, San Francisco CA

Printed in the United States of America

Library of Congress Catalog Card Number: 2007925866

For all general information contact Arcadia Publishing at:
Telephone 843-853-2070
Fax 843-853-0044
E-mail sales@arcadiapublishing.com
For customer service and orders:
Toll-Free 1-888-313-2665

Visit us on the Internet at www.arcadiapublishing.com

Dedicated to Reginald Pelham Bolton, civil engineer, historian, author, and resident of Washington Heights, Inwood, and Marble Hill.

CONTENTS

ACKNOWLEDGMENTS

Special thanks go to Eric Washington, author of *Manhattanville*, who was the first to give me encouragement on this project. Many thanks go to Michael Foltz and James Dykes of the *Washington Heights Citizen* and the *Inwood News* who started me on my career in writing on Washington Heights, Inwood, and Marble Hill. Their attitude was just do it. I must also acknowledge Dr. Gerald Gorin of the *Washington Heights and Inwood Report* who allowed me to be a columnist of historical stories for his paper.

I would like to acknowledge the members of Community Board, 12 whom I have known over the years and who have appreciated my work as district historian. I must also thank Manhattan borough historian Celedonia Jones and Bronx County historian Lloyd Ultan, who had every faith in me in knowing that I could get the job done and be in the vanguard of historical duties. Also to Stanley Michels, who knew I could be better than I am. To my wife, Shirley, much love and thanks for putting up with me over the years.

I am in debt to the members of the Kingsbridge Historical Society, the Washington Heights Historical Society, and the Harlem and the Heights Historical Society for showing me the way. Also, thanks goes to the Washington Heights Neighborhood Association and the Friends of Bennett Park for allowing me to be a part of their respective organizations and for their help in promoting Bennett Park, the site of Fort Washington, where the last battle for American independence was fought in New York City.

I would like to extend my gratitude to Joseph and Marguerite Hintersteiner of Arts Interaction the Washington Heights and Inwood Council on the Arts who have given me the opportunity to exhibit with them and act as resident historian for the organization. To Carol Weinstein, founder of Friends of Fort Tryon Park, many thanks for allowing me to participate as a committee member for the 50th anniversary celebration of the opening of the park in 1985.

For the resources extended to this project I am indebted to Reginald Pelham Bolton (1856–1942), civil engineer, historian, archaeologist, author, and resident of Washington Heights, Inwood, and Marble Hill. His book, *Washington Heights Manhattan, It's Eventful Past*, was the start of a long historical relationship over the centuries. This book is posthumously dedicated to him.

INTRODUCTION

For eight decades there was only one book that, for the most part, covered this part of Manhattan specifically from 155th Street to the Spuyten Duyvil Creek. Reginald Pelham Bolton's *Washington Heights Manhattan, Its Eventful Past* is considered one of the few books that was researched and devoted to this area. The book was published and distributed by the Dyckman Institute in 1924.

Northern Manhattan's topography, demographics, boundaries, and geography have changed many times in the past 500 years. From its pre-Columbian inhabitants to its present-day immigrants, the community is still a vibrant place to live. Currently the boundaries start at 155th Street from the Hudson to the Harlem Rivers to the Spuyten Duyvil Creek. Marble Hill is the landlocked portion of Manhattan connected to the Bronx.

Many of its noted residents, such as Henry Kissinger, Dr. Ruth Westheimer, Duke Ellington, Edwin Newman, Alan Greenspan, Tiny Tim, Lee Grant, Jean Arthur, Guy Williams, and Paul Robeson, have made major contributions to the world at large. Films and television shows such as *Law and Order*, *Coogan's Bluff*, *The Wrong Man*, *The Seven-Ups*, *Copland*, and many others have been filmed in Washington Heights and Inwood.

We must now think of the future, and this book will help bring new insights and a better understanding of the history to the future generations who will move into these communities.

One

WASHINGTON HEIGHTS

Washington Heights is noted for its hills, valleys, parklands, and history. Noted for having the last major battle of the Revolutionary War in New York City, the site of Fort Washington, located in Bennett Park, is considered by many local history enthusiasts to be the Alamo of the American Revolution.

Washington Heights has been inhabited as far back as the pre-Columbian period. The Lenape Confederacy, an Algonquin-speaking nation, used the area for fishing and trading. The area was part of a village called Nieuw Haarlem, established by the Dutch in 1658, to be used as a northern defensive post against Native American raids and as a farming community.

In 1664, the British took control of New York and its environs, and Nieuw Haarlem was renamed Lancaster, with a definitive boundary from East 74th Street and the East River to 129th Street and the Hudson River. It became a farming community until 1837, when the Harlem River Railroad was extended north through the area.

Mass transit played an important roll in the urbanization of Washington Heights. In the 1880s, trolley lines had been extended into northern Manhattan. There was a trolley barn on 218th Street and Broadway that housed the trolleys for the Third Avenue Railway Company.

As time progressed and people moved into northern Manhattan, the demographics of the community changed. The census counts showed the ever-increasing population, and areas were rezoned to show the changes. As a result of these districts, the official southern boundary of Washington Heights became 155th Street, and the area was designated Community District 12.

Washington Heights is experiencing a renaissance. For years it was teetering as an entity, and now with this revival comes gentrification and urban renewal. The rents are still affordable, and families have moved into Washington Heights from other parts of Manhattan. Actors, artists, and musicians are also moving into this little-known enclave that had gone unnoticed for years.

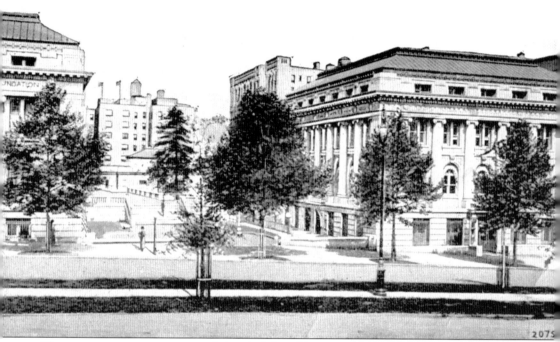

These two museums are part of the Audubon Terrace Museum Complex originally called Audubon Park. It was part of the estate of John James Audubon, who was famous for his book *The Birds of America*. It was conceived by Archer M. Huntington and laid out in 1908 by Charles Pratt Huntington. The statues in the courtyard were executed by Anna Vaughn Huntington. The timing of this complex was to coincide with the opening of the subway. The museum complex also housed the numismatic society, Hispanic society, and the American Academy and Institute of Arts and Letters. The Church of the Esperanza, which is also part of the complex, was consecrated on May 20, 1912.

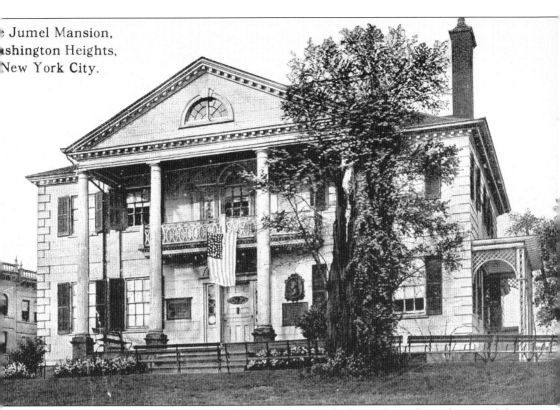

Jumel Mansion,
shington Heights,
New York City.

The Morris-Jumel Mansion has appeared in many postcards dating from the early part of the 20th century. It was constructed in 1765 as a summer villa for Col. Roger Morris and his wife, Mary Philipse. The building was confiscated by the Americans at the beginning of the American Revolution and was used by Gen. George Washington for six weeks in the fall of 1776. After the surrender of Fort Washington in November of that year, it was used by the Hessians during the occupation of New York during the war. After the war, it became a tavern and was used as a private residence by Stephen and Eliza Jumel. In 1904, it became a museum operated by the Daughters of the American Revolution and has remained so ever since.

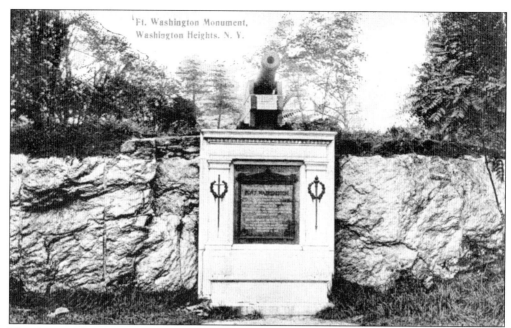

This memorial was constructed and dedicated in 1901 to honor the soldiers who fought during the Battle of Fort Washington. The property it was on was owned by James Gordon Bennett Sr. and James Gordon Bennett Jr. There was a cannon on top of the memorial in 1901 at the time of the dedication. It disappeared three years later and was never replaced. The property was acquired by the New York City Department of Parks and Recreation as a city park. In 2001, the memorial and the park were the site of an annual event honoring the fort, the battle, and the park.

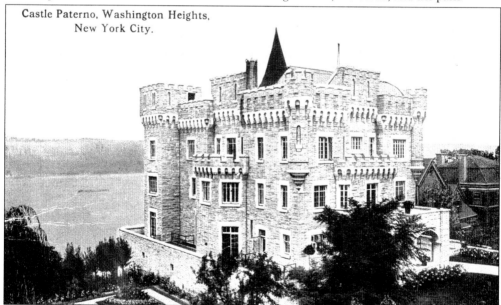

Castle Paterno, Washington Heights, New York City.

This castle was built by Dr. Charles V. Paterno, who went into the real estate business in New York with his brother Joseph. The castle was constructed in 1907 and had a fantastic view of the Hudson River. In the 1930s, Paterno razed his castle and built Castle Village. There are still some vestiges of the original estate on the grounds of the complex.

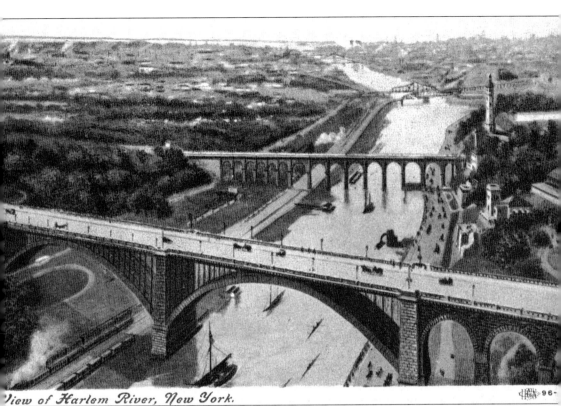

View of Harlem River, New York.

This 1910 postcard shows life on the Harlem River. The Washington Bridge, with automobiles and horse-driven carriages, can be seen in the foreground. Farther downriver is the Highbridge Aqueduct with a pumping tower and reservoir. On the Manhattan side of the river is the Harlem River Speedway that was used for trotter carriages. On the river itself sailboats and rowing teams can be seen. On the Bronx shore are trains operated by the New York and Hudson River Railroad Company that go between New York City and Albany. The railroad was eventually taken over by the Metropolitan Transportation Authority and is now known as Metro North.

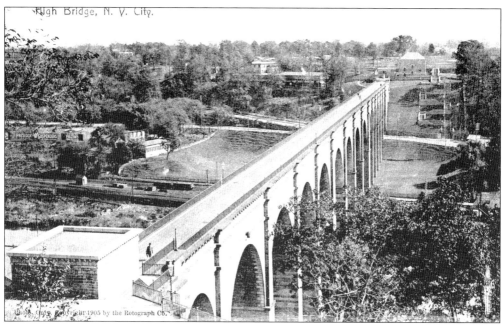

This view of the Highbridge Aqueduct is from Manhattan, showing the Bronx in the background. The aqueduct was designed by John Jervis and was completed in 1848. The Harlem River was dredged for improved shipping. Five of the central arches were removed, and a single steel-plate girder arch replaced them to allow for ships to pass under the aqueduct.

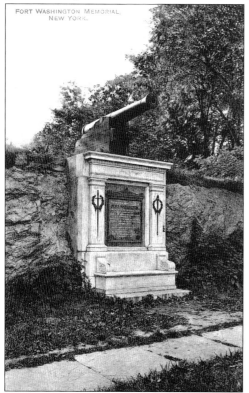

This memorial was dedicated on November 16, 1901, on the 125th anniversary of the Battle of Fort Washington. The plaque was placed there by the Sons of the American Revolution and through the generosity of James Gordon Bennett Jr., who owned the property as a summer estate originally purchased by his father in 1871.

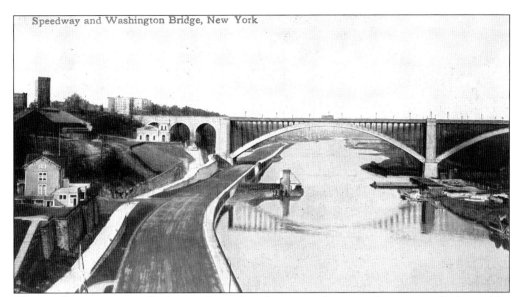

The speedway was originally designed as a place for trotting horses with carriages. Such notables as Cornelius Vanderbilt and resident C. K. G. Billings were seen on this tract of roadway. In time, cars had replaced the carriages and the speedway was incorporated into the F. D. R. Drive. The Washington Bridge was built to connect the Bronx with Manhattan and was opened in 1888. The bridge was designed by Charles Conrad Schneider. It originally had pedestrian walkways and carriages pulled by horses. The first automobiles were allowed on the bridge in 1906. As automotive traffic increased, the deck of the bridge was modified to a six-lane highway.

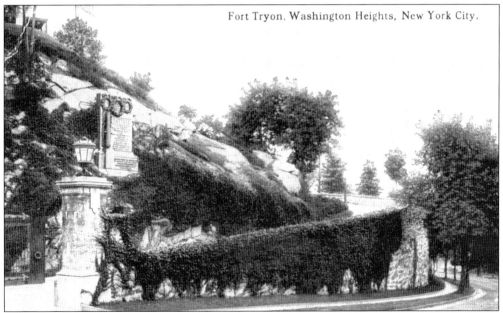

Fort Tryon, Washington Heights, New York City.

This is a postcard of what became Fort Tryon Park. The plaque was made to coincide with the Hudson-Fulton celebration in 1909 to commemorate the sailing up the Hudson River by Henry Hudson and the *Clermont*'s maiden voyage up the Hudson River in 1807 with Robert Fulton at the helm. The celebration lasted from September 25 to October 9, with a flotilla similar to the OpSail of America's bicentennial celebrations with onlookers on the shores of the Hudson River.

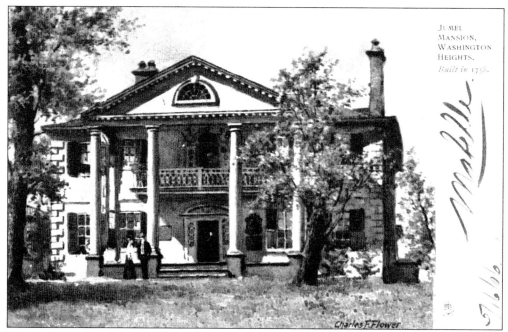

This postcard dated May 16, 1906, shows a painting of the mansion by Charles Flower. There were many postcards of the mansion in color and black and white and hand colored, but this is the only one of its kind.

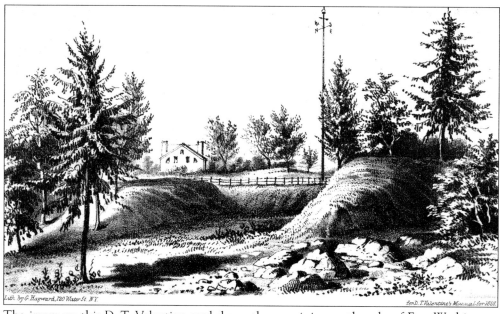

The image on this D. T. Valentine card shows the remaining earthworks of Fort Washington in 1856. In the background is the Moorewood residence, which was there until the 1880s. The property was purchased from Richard Carman by James Gordon Bennett Sr. for a summer estate in 1871. (Author's collection.)

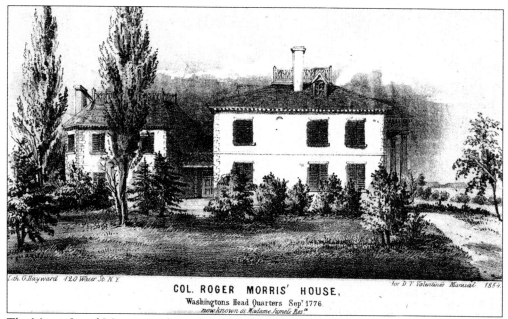

COL. ROGER MORRIS' HOUSE,
Washingtons Head Quarters Sep' 1776.
now known as Madame Jumels Res

The Morris-Jumel Mansion is shown here as it looked in the Colonial period when Washington used it as a headquarters. After the war it was a tavern known as Calumet Hall when Pres. George Washington brought his cabinet there for dinner. At the time this D. T. Valentine card was published, Eliza Jumel was living in the building. (Author's collection.)

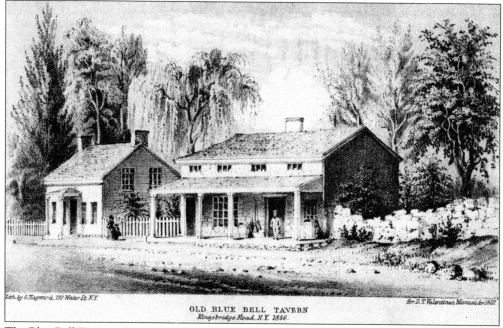

OLD BLUE BELL TAVERN
Kingsbridge Road, N.Y. 1856.

The Blue Bell Tavern, shown on this D. T. Valentine card, was located on the Kingsbridge Road, which by present-day standards is Broadway and 181st Street. Taverns of this type were used for social get-togethers and for business meetings. The site was used by Washington and his staff when the British evacuated New York. They stood in front of the tavern as they watched the American troops march south to retake New York City. (Author's collection.)

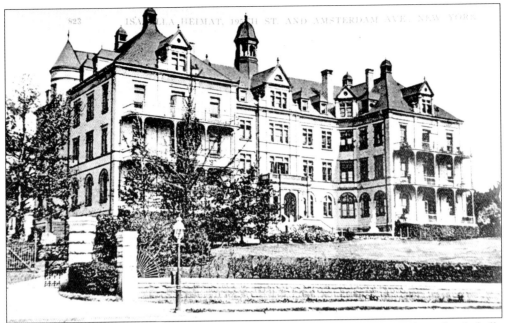

The Isabella Geriatric Center opened in Astoria, Queens, on May 15, 1875, as the Isabella Heimat Home. The home relocated to 186th Street and Audubon Avenue on November 19, 1889. It was a four-story building with a mansard roof where the offices and social hall were located on the first floor. The other floors were used for the residents. In 1969, the original building was razed to make way for the expansion of its facilities.

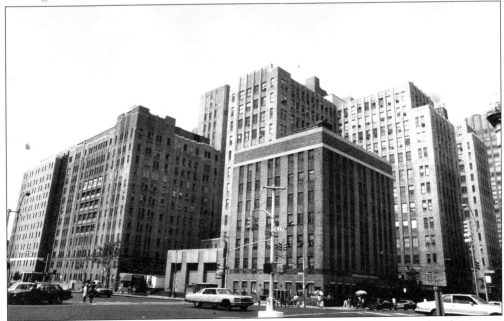

In 1868, the Presbyterian Hospital was founded and was located on 70th Street and Park Avenue. In 1911, the Presbyterian Hospital and Columbia University's College of Physicians and Surgeons entered into an agreement to improve medical services. In 1921, property was purchased at the former site of Hilltop Stadium, the home of the New York Highlanders.

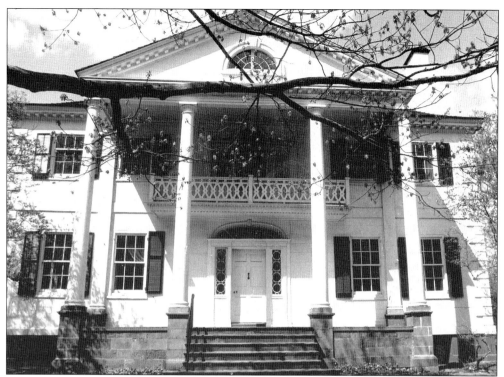

The Morris-Jumel Mansion is perched on a commanding rise with spectacular views of Manhattan to the south and the Bronx, Queens, and Long Island to the east. Prior to the American Revolution, the mansion served as a focal point of many of New York's most fashionable parties. During the war it was used by the British and the Hessian soldiers.

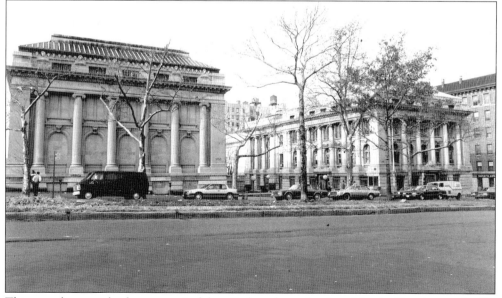

This complex was also known as Audubon Park and was developed by the Huntington family. Many of the statues were executed by Anna Vaughn Huntington. One of the most prominent is the statue of El Cid.

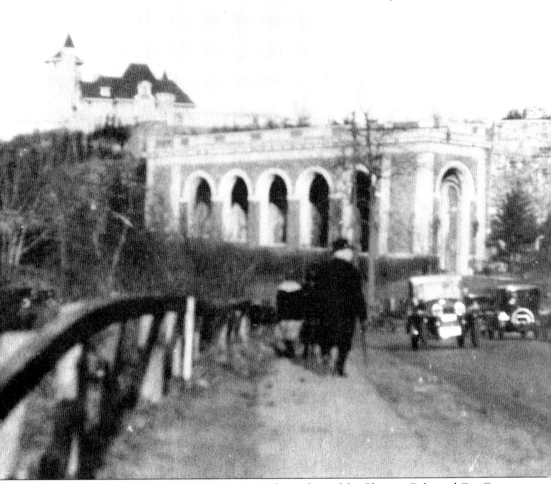

Cornelius Kingsley Garrison Billings, a retired president of the Chicago Coke and Gas Company, moved to New York City and purchased a house on Fifth Avenue and 53rd Street. He purchased 25 acres of land in Washington Heights and constructed a Louis XIV–style mansion designed by Guy Lowell. It had a galleried entranceway from the Henry Hudson Parkway that was 50 feet high and made of Maine granite. In 1917, Billings sold the land to John D. Rockefeller Jr. for $35,000 per acre. Tryon Hall was destroyed by fire in 1925. The Billings estate had a commanding view of the Hudson River with its gardens and beautiful driveway. One of the lesser-known facts of the estate is that it was the basis for the book *The Dragon Murder Case* by S. S. Van Dine where detective Philo Vance had to solve a murder on the grounds of the estate where a dragon was supposed to have lived.

The Little Red Light House and the Great Gray Bridge is a favorite children's story written in the 1940s. The book was based on a real lighthouse that is located under the George Washington Bridge. The lighthouse was built for the Sandy Hook Coast Guard Station. In time, the army took over the site as a practice range for artillery. It was dismantled and moved to Staten Island for storage. It was taken out of storage and moved to its present location as a lighthouse in 1921 and decommissioned in 1947. It is now part of the New York City Department of Parks and Recreation as a museum.

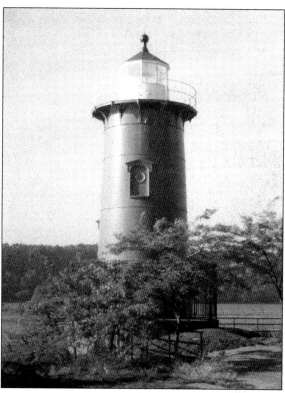

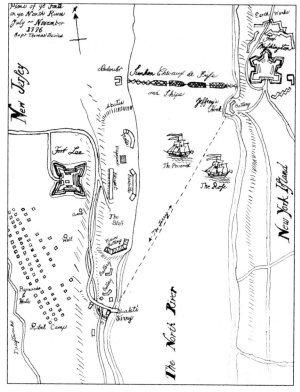

This map was drawn to show the military encampments and major fortifications in New York and New Jersey in July 1776. Capt. Thomas Davies was responsible for drawing this map. (Courtesy of the Fort Lee Historical Park.)

Francesca Xavier Cabrini was beatified as America's first saint. Born in Italy, she devoted her life to the church where she created the Missionary Sisters of the Sacred Heart of Jesus. At the urging of Pope Leo VIII in 1889, Cabrini went to America and started her missionary work in Chicago. In time, she became known as the "Patroness of Immigrants." Her organization opened 67 hospitals, nurseries, and schools. In 1899, Cabrini went to the Washington Heights section of Manhattan to find land for a new project, the Sacred Heart Villa. She purchased land owned by C. K. G. Billings, and the villa became a reality. The villa eventually became Mother Cabrini High School, and in 1960, a shrine was opened to house her remains, which were interred on the property in 1947 after a ceremony of canonization was performed there. John Cardinal O'Connor was the main participant in the 50th anniversary of her canonization.

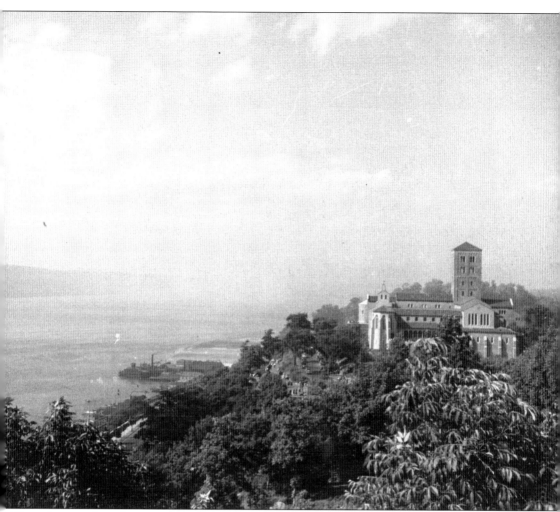

This photograph, taken in 1940, shows Fort Tryon Park, the Cloisters, and the Dyckman Street Ferry. The ferry landing was also used as a marina, which is still operational today with a restaurant located next to it. The ferry operated between 1915 and 1942, and some of its passengers were tea magnate Thomas Lipton, oil tycoon John D. Rockefeller Jr., and evangelist and former baseball star William (Billy) Ashley Sunday.

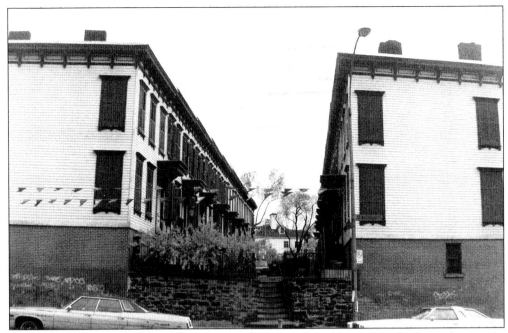

Sylvan Terrace was the original driveway for the Morris-Jumel Mansion, which can be seen in the background. The buildings are single-family, middle-class homes that were built in 1882. Originally built as rentals, the buildings became privately owned.

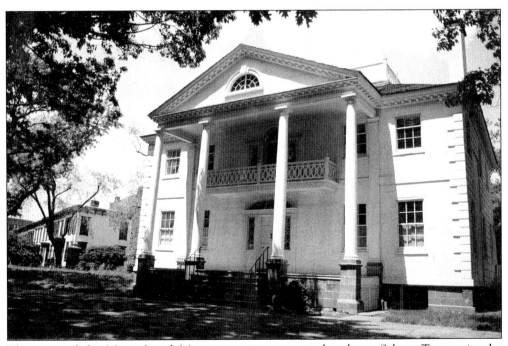

This view of the Morris-Jumel Mansion as it appears today shows Sylvan Terrace in the background. The mansion is the oldest mansion in Manhattan, dating from 1765.

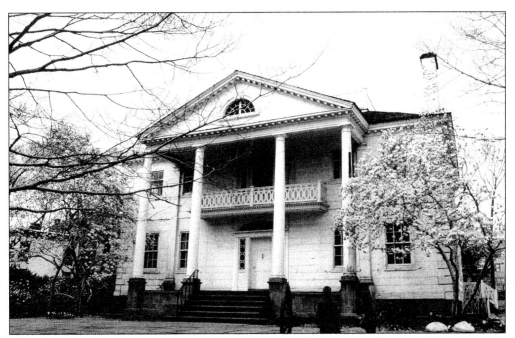

This view of the Morris-Jumel Mansion was photographed in the 1970s when there were cannons in front of the mansion to add flavor to its Revolutionary history. This photograph also shows lilac trees in front of the mansion.

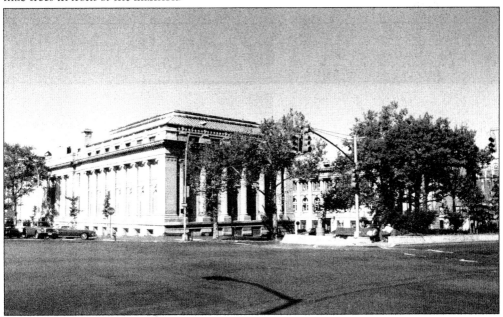

This complex initially was home to the American Geographical Society, numismatic society, Hispanic society, American Academy and Institute of Arts and Letters, American Indian Museum-Heye Foundation, and the Church of the Esperanza. The American Indian Museum was taken over by the Smithsonian Institution and relocated to Lower Manhattan. The main museum is in Washington, D.C. The numismatic society also left the complex to new quarters in Lower Manhattan.

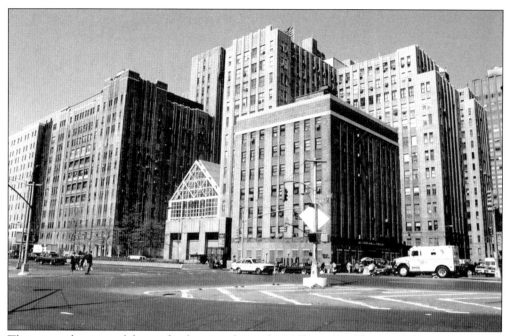

This particular view of the medical center shows the Milkman Building and the district health center in the foreground. The rest of the center provides for all types of medical maladies, ailments, syndromes, and other infectious diseases.

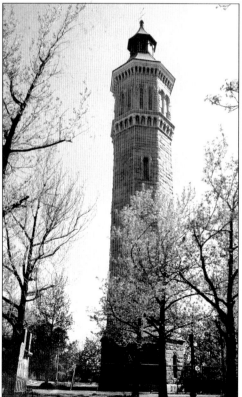

The Highbridge Water Tower served as a pumping station for the reservoir in Highbridge Park. Water was at a premium in New York City, and a system was designed to send water from Westchester through the Bronx over the Harlem River through pipes on the Highbridge Aqueduct and then to Lower Manhattan.

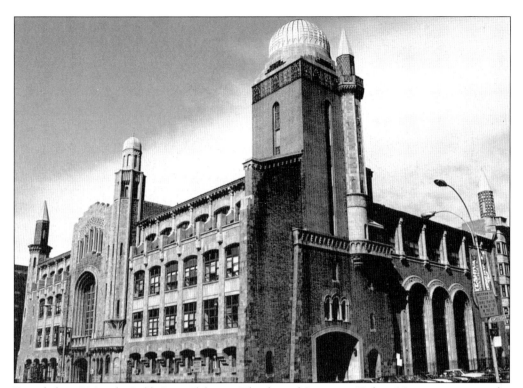

Founded in 1896 as the Rabbi Isaac Elchanan Theological Seminary, Yeshiva University remains the oldest center for Judaic studies in the United States. Over the years the university has branched out into other fields of study for its students. The present campus on Amsterdam Avenue and 185th Street was opened in 1928 with an architectural design of Near and Middle Eastern architecture. The Yeshiva University Museum was on the main campus until it moved to west 17th Street.

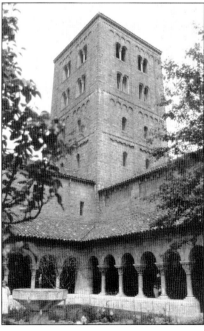

The Cloisters, opened in May 1938, has been the centerpiece of Fort Tryon Park. It is the most visited attraction in northern Manhattan. The core collection of the museum was put together by sculptor George Grey Barnard, who went to Europe to collect specimens for his museum, which was on Fort Washington Avenue and 190th Street.

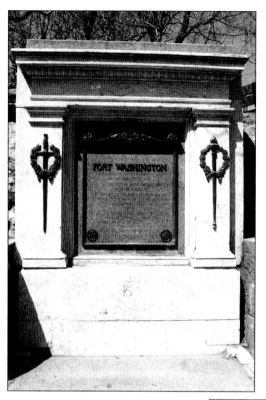

This memorial was dedicated on November 16, 1901, for the celebration of the 125th anniversary of the Battle of Fort Washington. It was erected by the New York Chapter of the Sons of the American Revolution and through the generosity of James Gordon Bennett Jr. Originally the memorial had a cannon from the Mexican War period on top and a seat at the base. The icons on the left and right side of the plaque are War and Victory, respectively.

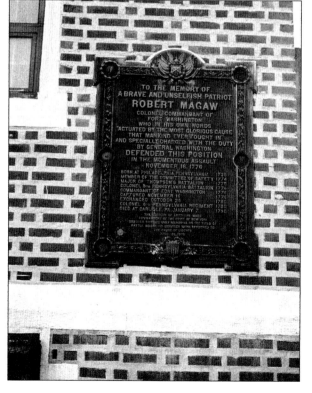

This plaque, cast in 1923, is dedicated to Col. Robert Magaw, who was the commanding officer during the battle and eventual surrender of Fort Washington. He was taken prisoner and with his fellow patriots was sent to the prison ships in New York Harbor. Magaw was eventually released in a prisoner exchange.

This plaque was made to honor the men and women who fought in the area on November 16, 1776, and was placed in conjunction with the Hudson-Fulton celebration in 1909 honoring the *Clermont* and the *Half Moon* sailing up the Hudson River. There are plans to celebrate Hudson's trip up the river that honors him in 2009.

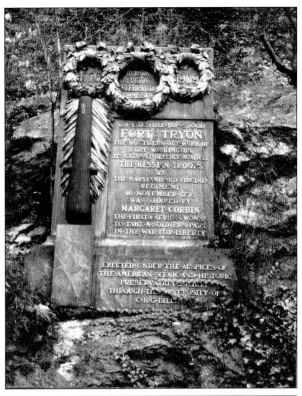

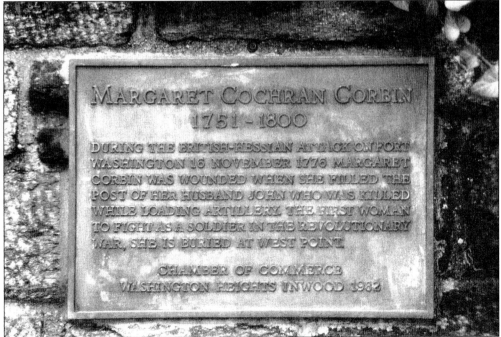

This plaque was cast and placed at Margaret Corbin Circle by the Washington Heights Chamber of Commerce. The plaque describes Corbin taking over her husband's cannon after he was shot dead from a musket ball.

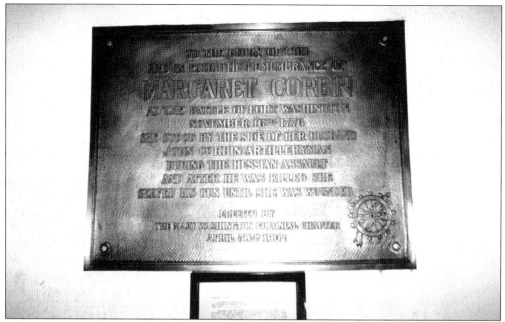

This plaque was cast for the Holyrood Church on 179th Street and Fort Washington Avenue on April 30, 1902, by the Mary Washington Chapter of the Daughters of the American Revolution. The plaque honors Margaret Corbin's bravery and her willingness to stand by her husband after he was mortally wounded operating his cannon. Corbin had taken over firing the cannon, and she was severely wounded by grapeshot.

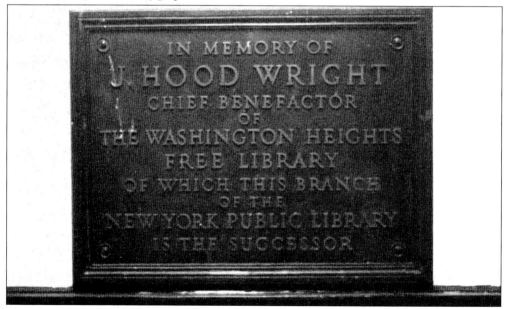

This plaque is prominently displayed at the entrance to the Washington Heights branch library at St. Nicholas Avenue and 160th Street. James Hood Wright was a banker from Philadelphia who lived on what is now Haven Avenue and 175th Street. He was also a philanthropist who donated money for education as well as for funding a hospital in the Manhattanville section of Manhattan.

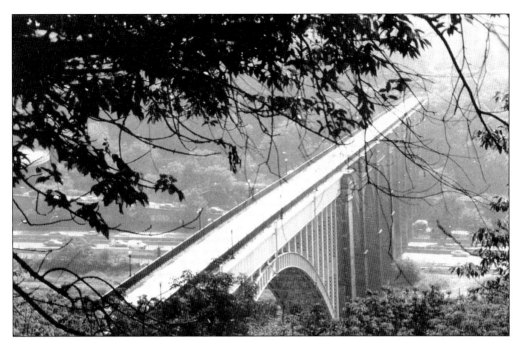

This view of the aqueduct shows how it was rebuilt to conform to the dredging and widening of the Harlem River. Even though it is closed to the public, the Urban Park Rangers occasionally open it from the Bronx side to allow visitors to see the vistas. Edgar Allan Poe was inspired by the bridge for his literature and poems when he lived in the Bronx.

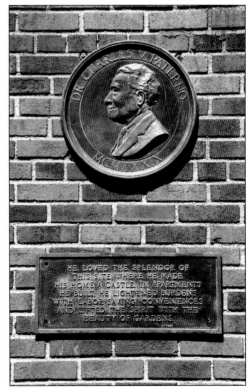

Castle Village was the site of Paterno Castle where Dr. Charles V. Paterno made his home in 1907. In the late 1930s, Paterno razed his castle to make way for the Castle Village complex. Paterno was a physician by training but went into the real estate business with his brother Joseph. The plaque was placed by the residents to show their appreciation to him.

Dedicated to
Columbia-Presbyterian
Medical Center
and the community of
Washington Heights
by the New York Yankees
to mark the exact location of
home plate in Hilltop Park,
home of the New York Highlanders
from 1903 to 1912,
later renamed the New York Yankees

On September 30, 1993, a special ceremony took place on the grounds of the medical center. This ceremony marked the 90th anniversary of the American League's beachhead in New York City. One of the persons in attendance was Chester "Red" Hoff, who at the time was the oldest living Major League Baseball player at 102 years of age. Huff was one of the New York Highlanders when the team became the Yankees. Hoff was a pitcher for the Highlanders who, 84 years prior to the ceremony, took to the mound against the Detroit Tigers. Unbeknownst to him, Hoff was facing the legendary hitter Ty Cobb for the first time. Hoff had struck out Cobb and did not find out who the hitter was until the following day when he read the *New York Journal*'s sports headline "Ty Cobb Struck Out." This plaque was placed as a memorial and honorarium to the Yankees. The Highlanders played there from 1903 to 1912.

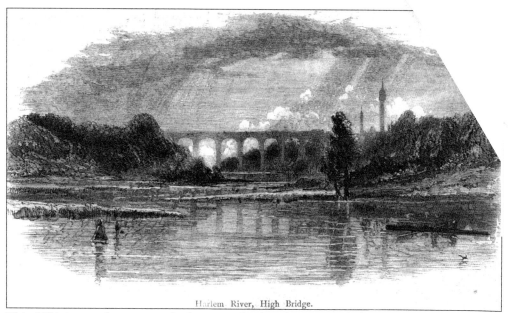

Harlem River, High Bridge.

This 1874 image shows a southerly view of a bucolic scene of the Harlem River with the Highbridge tower.

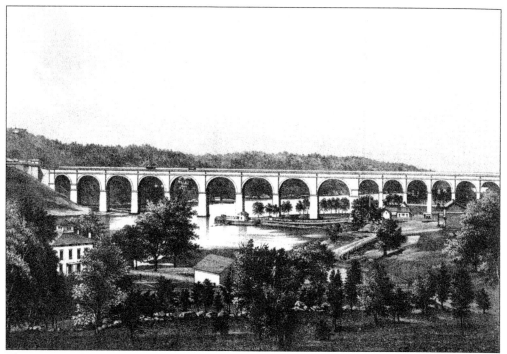

This is a northwesterly view of the Highbridge Aqueduct from the Bronx shoreline in 1862 with horse-drawn vehicular traffic. The image shows what life was like on the Bronx side of the Harlem River in the 1860s. The Harlem River was dredged and expanded in the 1920s to improve navigability around Manhattan. It also affected many lives and companies that were a part of the life of the river over the years.

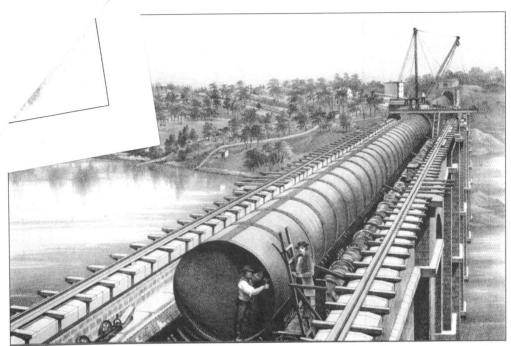

This 1862 lithograph shows the aqueduct pipes being constructed to allow water to come into New York City from the Croton Reservoir system in Westchester. The Bronx can be seen in the background.

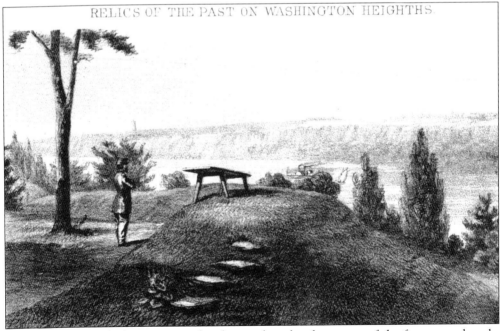

RELICS OF THE PAST ON WASHINGTON HEIGHTS

This 1864 lithograph shows typographical errors but also shows part of the former earthworks of Fort Washington. The Chittenden estate was around what is now 187th Street west of Fort Washington Avenue. The actual remains of the site of Fort Washington itself are located in what is now Bennett Park on Fort Washington Avenue between 183rd and 185th Streets.

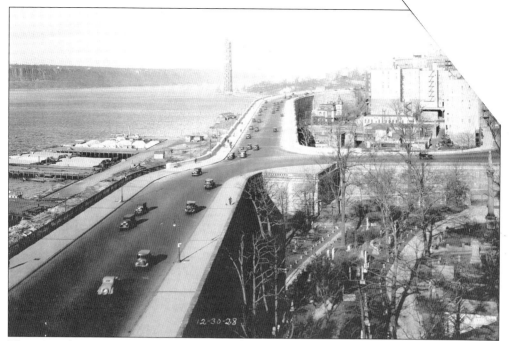

This 1928 photograph shows Trinity Cemetery in the foreground and the Manhattan tower of the George Washington Bridge in the background. The Victorian mansion is in the center, as is the William Wheelock home. Wheelock was a neighbor of John James Audubon. The house was eventually razed to make way for new apartment buildings that are currently there.

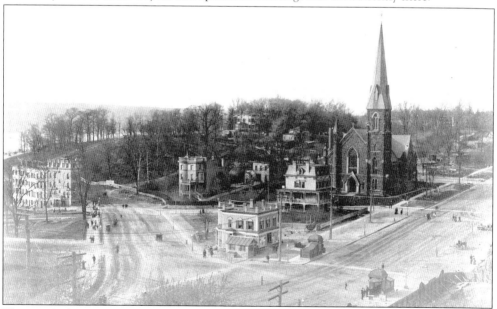

This 1905 photograph shows the second Church of the Intercession, which was replaced in 1911 by the present structure on 155th Street and Broadway. Note the kiosks of the 157th Street station of the Interborough Rapid Transit Subway, which was extended to 242nd Street. Since this photograph was taken, there was mass land speculation for apartment buildings that changed the face of the neighborhood.

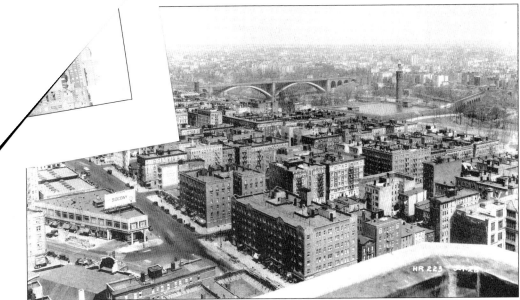

This 1928 northeasterly view of Washington Heights is from 168th Street looking toward the Bronx and the Harlem River. Shown in the background on the Harlem River are the Washington Bridge (not to be confused with the George Washington Bridge on the Hudson River) and the Highbridge Water Tower with the reservoir.

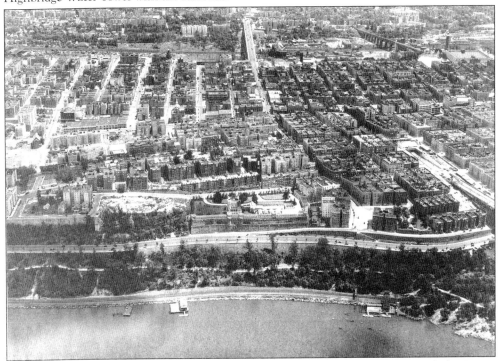

This 1935 aerial view covers 173rd to 187th Streets. The view is looking toward the Bronx with the Harlem River dividing the two boroughs. In the foreground is Paterno's Castle, which will eventually be replaced with Castle Village. To the right is the Manhattan approach of the George Washington Bridge.

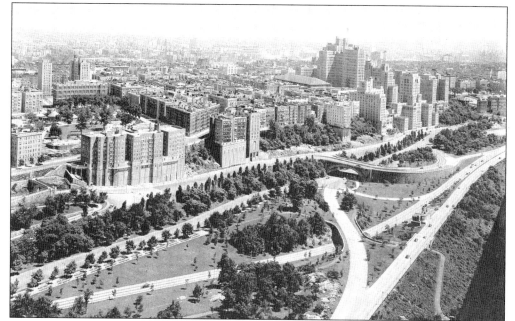

This 1935 photograph was taken from the Manhattan tower of the George Washington Bridge looking toward the Columbia University Medical Center. The highway approaches and the Henry Hudson Parkway can be clearly seen in Riverside Park. Also shown is a gasoline station that was razed when the lower level was built and new roads were constructed to connect with the George Washington Bridge.

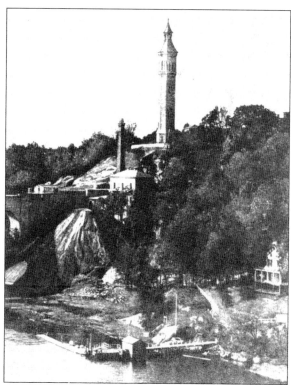

Highbridge tower was built in 1871 as a pumping station for the reservoir, which had a capacity of 10.8 million gallons of water. A five-octave carillon was added to the tower in 1958 by the B. Altman Foundation. The chimes were heard in Manhattan and the Bronx, especially at dinnertime when the carillon reminded the children at the pool that it was time to go home. The tower was given landmark status in 1969 by the New York Landmarks Preservation Commission. The tower was badly damaged in 1984 by a fire that was started by vandalism. Funds were raised by then–city councilman Stanley Michels to rebuild and repair the tower. The Urban Park Rangers open the tower for tours on a regular basis.

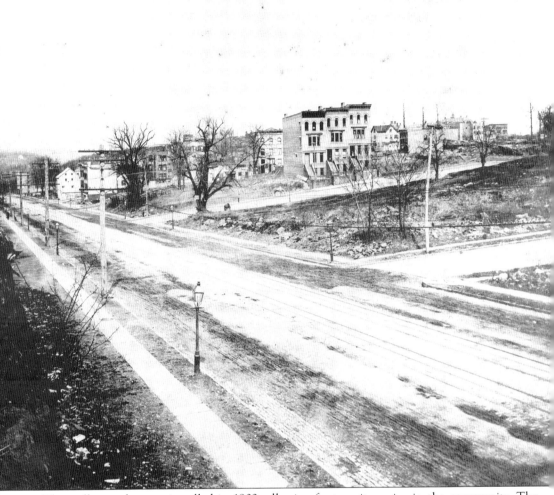

The trolley tracks were installed in 1902, allowing for transit service in the community. The three attached four-story buildings in the middle of the picture are on 183rd Street between Broadway and Wadsworth Avenue and are the start of residential development. These buildings are still standing today.

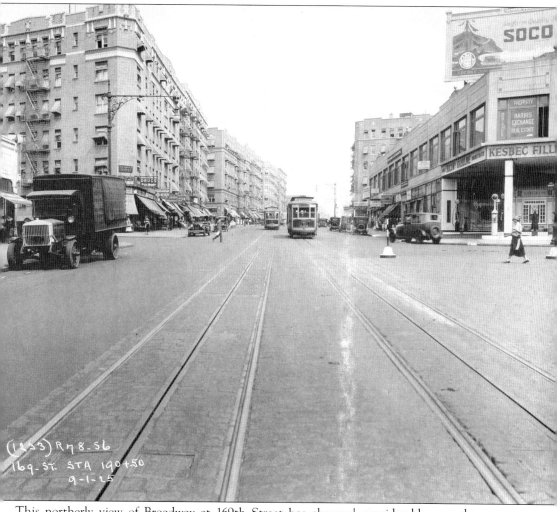

This northerly view of Broadway at 169th Street has changed considerably over the years. Photographed in 1926, there is a gas station on the right that has long since gone out of business. A MacDonald's restaurant has taken its place. On the left is the Uptown Movie Theater that closed in 1969 and was replaced by a supermarket.

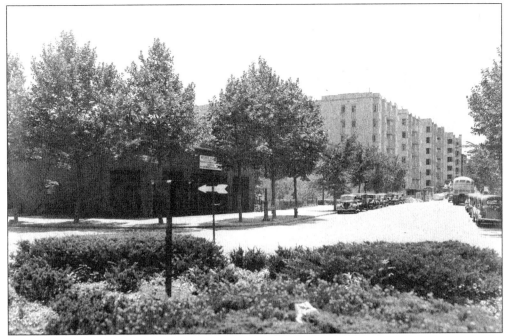

This photograph shows the northern end of Fort Washington Avenue at 190th Street. At the rear on the left is the 190th Street entrance to the Independent Line A subway. To the right are art deco buildings that are common for this part of Washington Heights. Also shown is a double-decker bus that was common for the period. This type of bus went down Fifth Avenue.

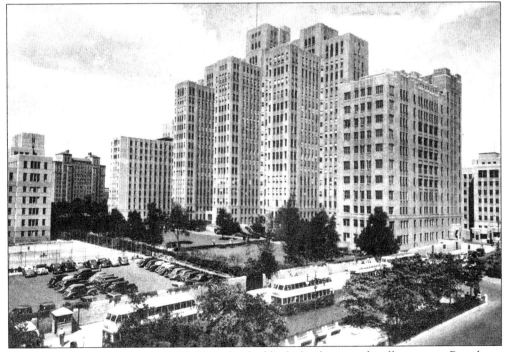

This photograph was taken in 1944. Note the double-decker buses and trolley cars on Broadway. The seats in the Broadway mall are no longer there.

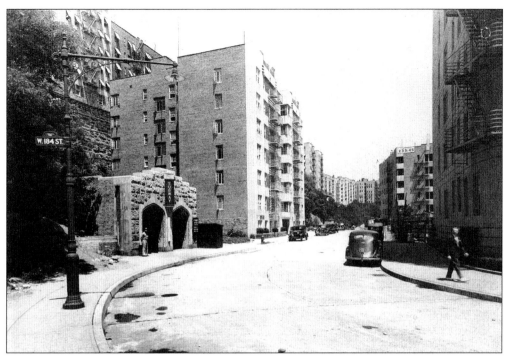

This 1939 photograph shows the entrance to the 181st Street Independent Subway station. Overlook Terrace is noted for its many art deco buildings that were constructed during this period.

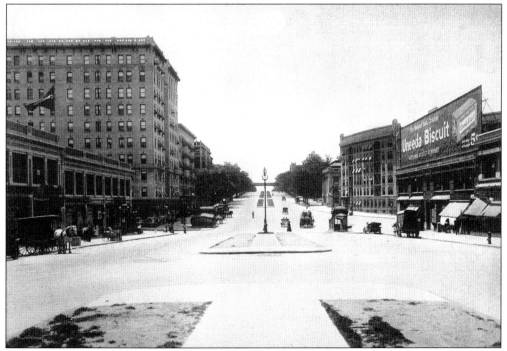

This 1911 photograph looks south on Broadway toward Trinity Cemetery in the background. Note the bridge that connects the eastern and western divisions of the cemetery. The Uneeda Biscuit billboard is no longer on top of the building.

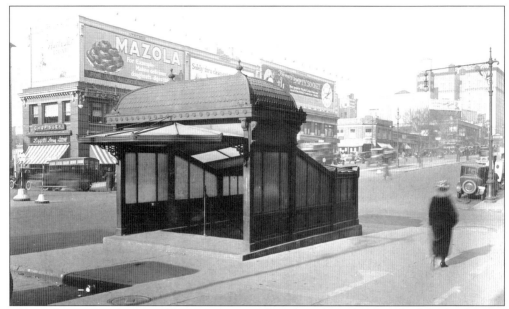

The predominant subject in this 1924 photograph is the subway kiosk. All of the kiosks were taken down in the late 1950s. The building across the street shows the Liggett's Drug Store at the corner with a Chinese restaurant on the second floor. On the right toward 160th Street is the Loew's Rio Movie Theater. The building still stands, but the theater has closed and is now a supermarket.

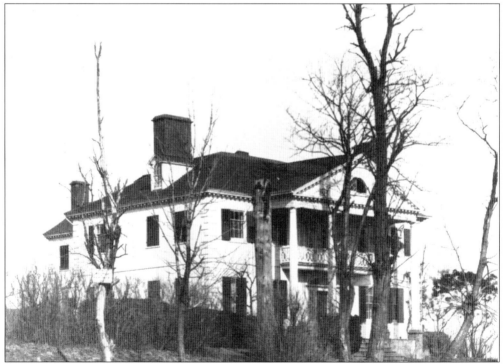

This photograph shows the Morris-Jumel Mansion as it was when still under private ownership in 1895. It became a museum a decade later, and the grounds were groomed to reflect it.

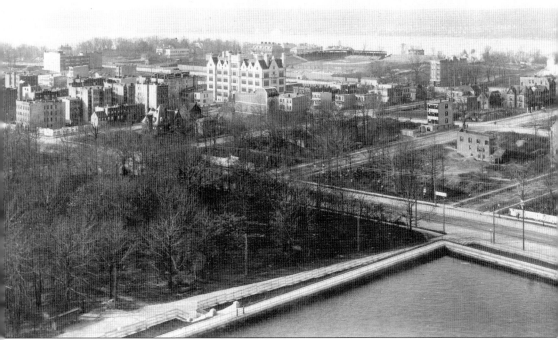

This 1905 photograph shows what the area of southern Washington Heights looked like before it became fully developed and before the medical center was constructed. The large white building is Public School 168, and behind it is Hilltop Stadium where the New York Highlanders played from 1903 to 1913. They eventually were bought by Jacob Ruppert, and the name of the team was changed to the New York Yankees.

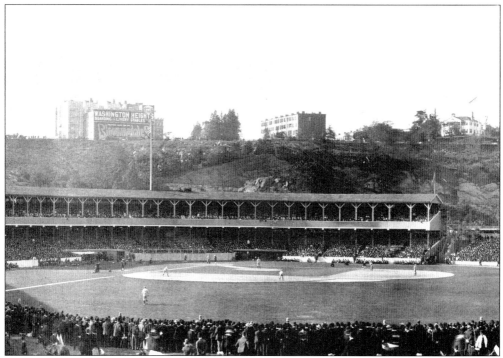

This 1905 photograph was taken from 158th Street and Eighth Avenue showing one of the games from the 1905 World Series. This particular stadium burned in 1911 and was rebuilt. The New York Giants were there from 1890 until they left for California in the 1950s. The New York Yankees played there from 1913 to 1922, until Yankee Stadium opened in 1923.

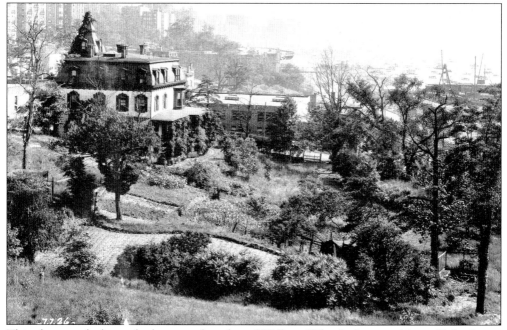

This photograph shows the home and garden of William Wheelock, a neighbor of John James Audubon, whose home was immediately south of the Wheelock residence.

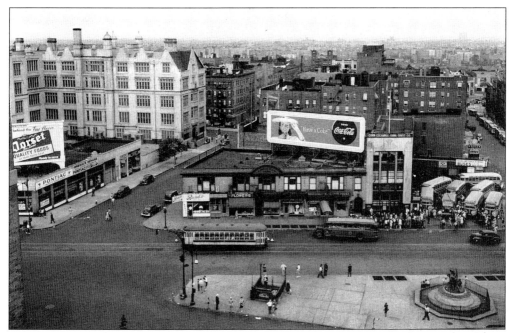

This 1950 photograph shows Public School 168, the bus depot for the buses going to New Jersey, and the Corn Exchange Bank, which eventually became Chemical Bank. Chemical Bank was taken over by J. P. Morgan-Chase. That particular block was demolished for the Russ Berry Medical Research Building. In the foreground on the right is the Washington Heights and Inwood World War I Memorial.

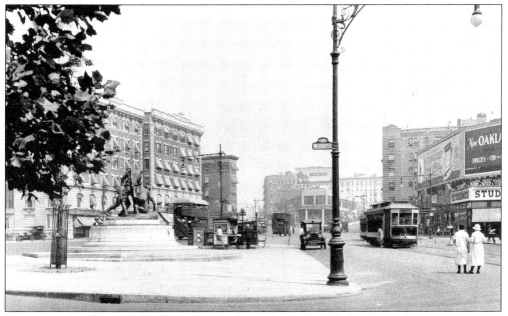

This particular photograph, taken in 1925, shows the World War I memorial with a newsstand and subway entrance at the north end of the triangle. In the background is the intersection of Broadway and St. Nicholas Avenue. Note the double-decker buses and trolley car, which were the main means of street transportation.

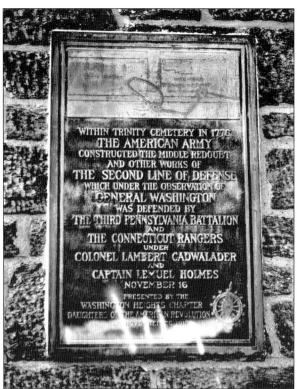

This plaque was placed on the back wall of the Church of the Intercession to honor the men defending the second line of defense of Fort Washington on November 16, 1776. The plaque is no longer there.

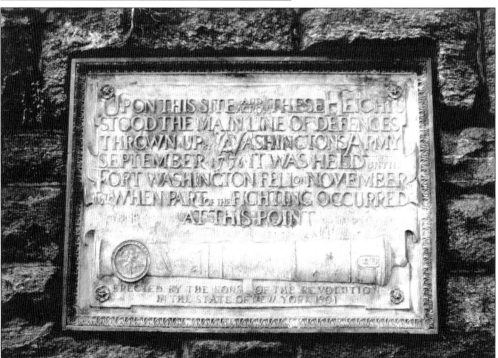

This plaque is located on 153rd Street and Broadway and was placed there by the Sons of the American Revolution in 1901. It honors the men who fought in the Battle of Fort Washington.

This plaque is in the eastern division of Trinity Cemetery uptown. It was placed there by the Washington Heights Chapter of the Daughters of the American Revolution on May 5, 1920. According to the plaque, the fiercest fighting took place here.

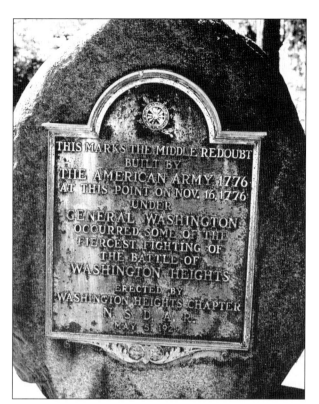

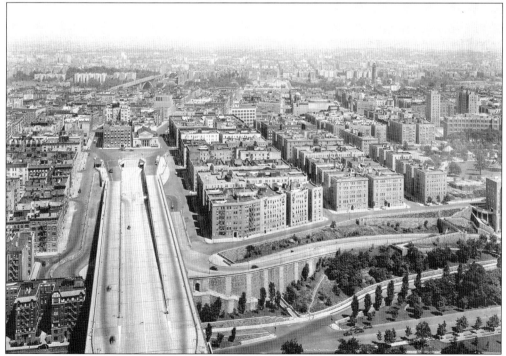

This 1935 view from the George Washington Bridge shows Washington Heights and the Manhattan approach of the bridge in the foreground. The Bronx can be seen in the distance.

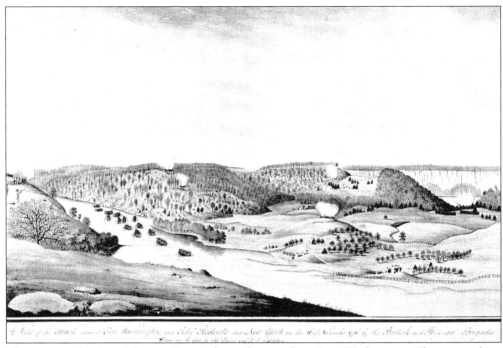

This painting by Capt. Thomas Davies shows the assault on Fort Washington. The view is from the Bronx to Manhattan.

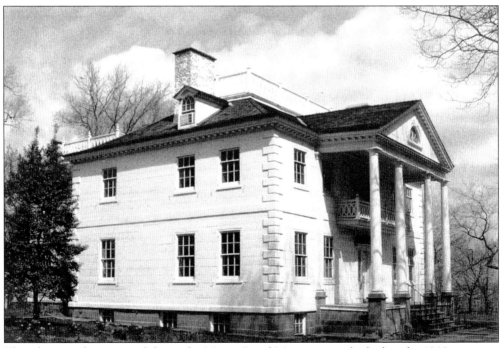

This photographic postcard shows the Morris-Jumel Mansion as it looked in the 1940s.

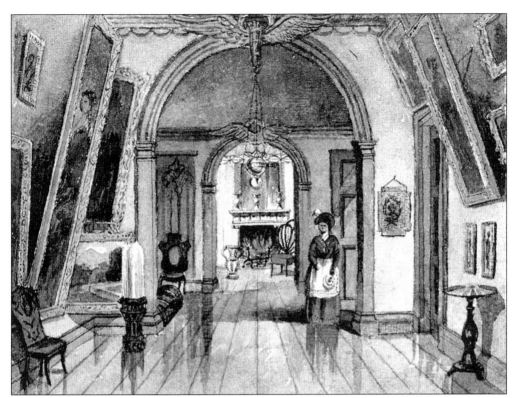

This postcard shows the main hall of the mansion.

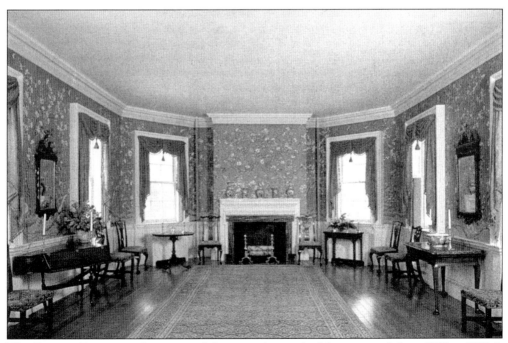

The Octagon Room was the center of the party during the Morris period, from 1765 to 1775. It is the only room of its kind in New York City.

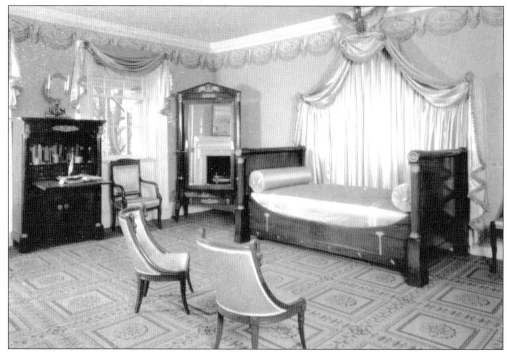

This postcard shows what Eliza Jumel brought back with her after her trip to France. The bed is said to have been Napoleon's.

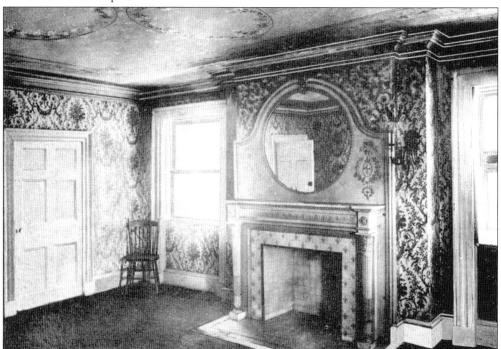

This postcard depicts the Washington Bedroom at the Morris-Jumel Mansion, which George Washington used during his stay there from September to October 1776 during the Battle of Harlem Heights.

This postcard depicts the main altar of the Church of Our Lady Esperanza. The church is located on 156th Street between Broadway and Riverside Drive and is part of the Audubon Terrace Museum Group.

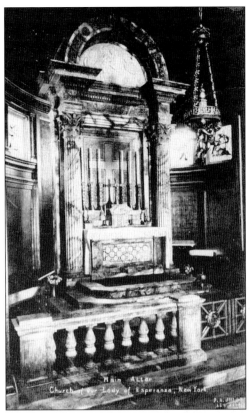

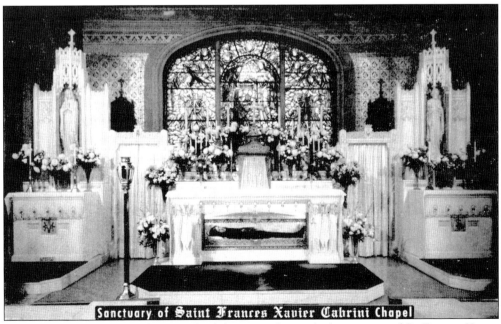

This postcard is of a 1947 photograph of the main altar with the remains of St. Frances Xavier Cabrini. Even though she was born in Italy, she died in the United States and was the first American to become a saint. The second person to be sanctified was Elizabeth Seton.

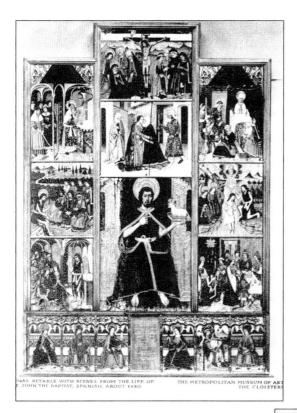

This postcard shows a retable with scenes from the life of St. John the Baptist. It was painted by an unknown Spanish artist in about 1480 and is house in the Cloisters Museum.

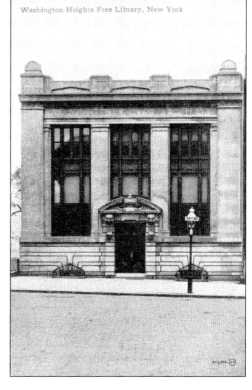

This building, which still stands today, is located on St. Nicholas Avenue between 157th and 158th Streets. It received a generous donation by James Hood Wright and has eventually become the Washington Heights Branch of the New York Public Library.

This 1880 lithograph shows passengers on a pier going to a steamboat for an excursion downriver on the Harlem River.

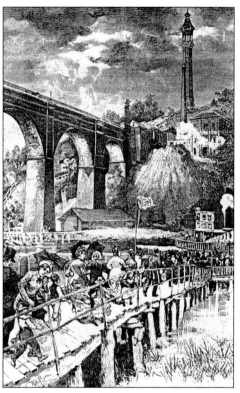

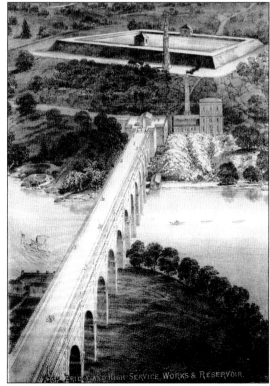

This 1880 overview of the Highbridge complex looks west from the Bronx. This scene shows how the area looked before being developed.

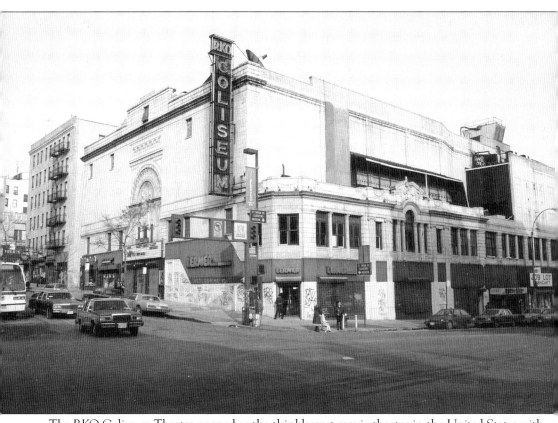

The RKO Coliseum Theatre opened as the third-largest movie theater in the United States with 3,000 seats. It served the community as a movie theater and a location for graduation ceremonies.

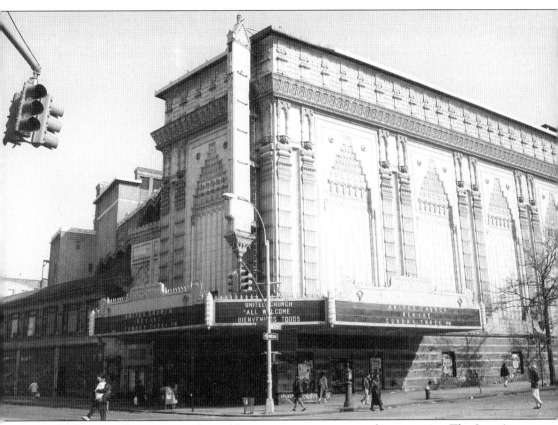

Loew's 175th movie theater opened to add more movies to a starved community. The Loew's 175th eclipsed the RKO Coliseum Theatre as the third-largest theater with 600 more seats. It closed in 1967, and two years later Rev. Frederick Eikerenkoetter (also known as Reverend Ike) took over the building.

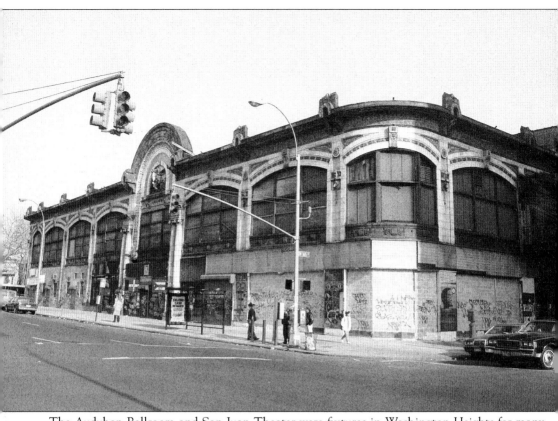

The Audubon Ballroom and San Juan Theater were fixtures in Washington Heights for many years. The building was originally built by William Fox in 1921 as the Audubon Movie Theater, which had 2,368 seats and brought vaudeville and movies to Washington Heights. Upstairs, the ballroom held social occasions. The Transport Workers Union that ran the New York City buses and subways got its start there. On February 21, 1965, Malcolm X was assassinated at the Audubon during a rally. The building was razed, and the only remains are the Broadway facade of the May Lasker Biomedical Research Center.

This monument was constructed in 1910 by the Washington Heights Chapter of the Daughters of the American Revolution. The monument honors the fact that the site was a rifle redoubt during the Battle of Fort Washington on November 16, 1776.

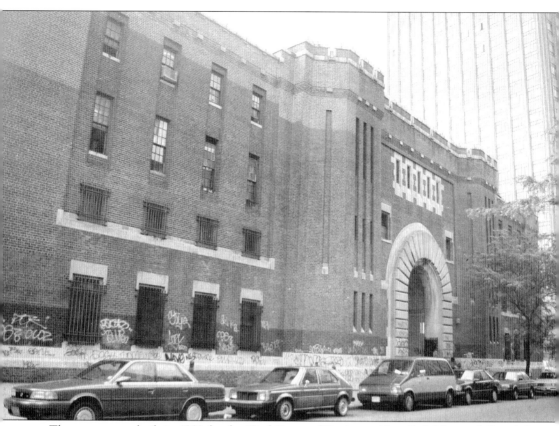

The armory was built in 1903 for the 22nd Corps of Engineers New York National Guard. It is now used as a track-and-field center.

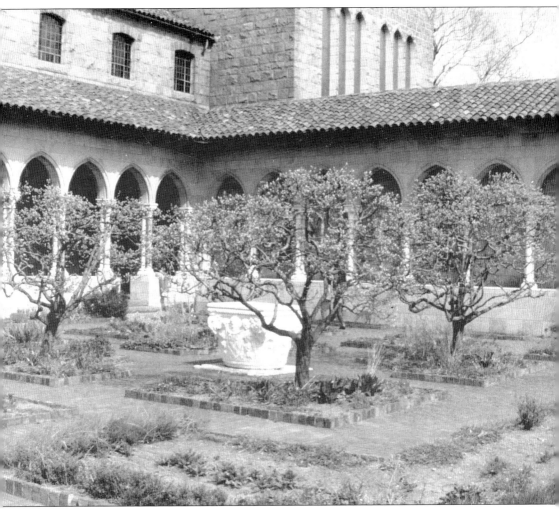

The Bonnefont Cloister is open to the public at the Cloisters Museum of the Metropolitan Museum of Art in Fort Tryon Park.

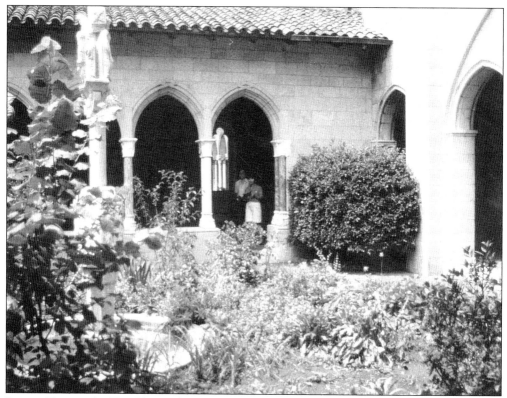

Pictured here is the Trie Cloister located at the Cloisters Museum in Fort Tryon Park.

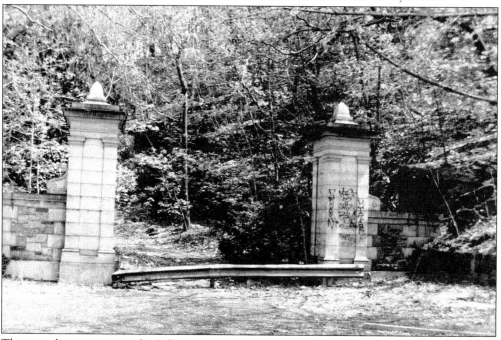

This was the entrance to the Billings estate, which is now Fort Tryon Park. The entrance was located on the uptown drive of the Henry Hudson Parkway.

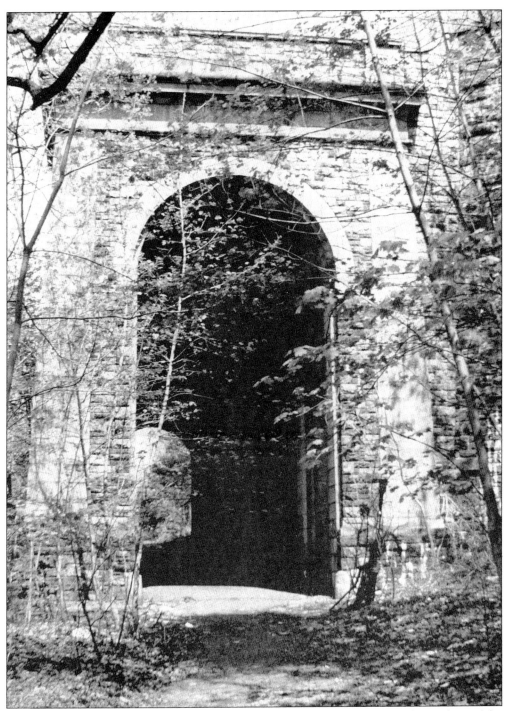

Pictured here is the driveway under the overlook toward the Billings estate. The roadway of the drive was made up of fire-baked bricks, which were covered over during the construction of Fort Tryon Park. The bricks were recently uncovered and renovated to show their true beauty. One of the scenes from the movie *Coogan's Bluff* starring Clint Eastwood was filmed at this location.

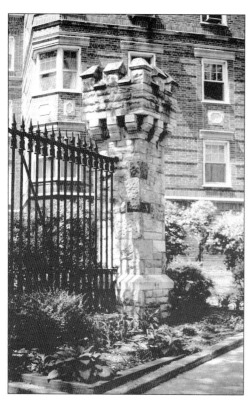

This was one of the remaining pieces of the Paterno estate after the Paterno Castle was torn down to create Castle Village.

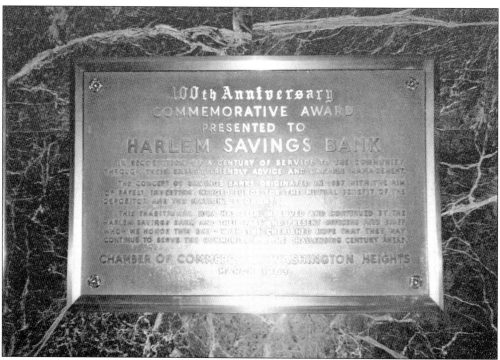

This plaque was dedicated by the Washington Heights Chamber of Commerce in March 1963, honoring the many years of service of the Harlem Savings Bank to northern Manhattan.

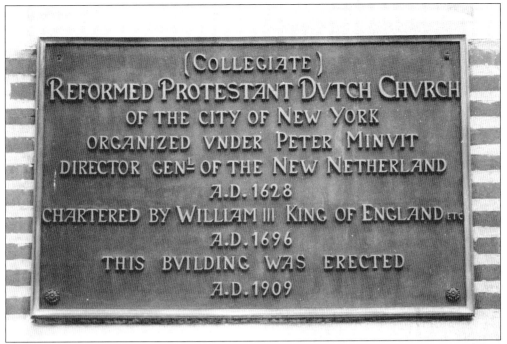

This plaque is on the wall of the Fort Washington Collegiate Church at 181st Street and Fort Washington Avenue. The plaque honors the Reformed Protestant Dutch Church, one of several Dutch Reformed churches in New York City.

The Winston Churchill plaque is located in Holyrood Church on 179th Street and Fort Washington Avenue. It honors Churchill as a warrior statesman.

FORT·TRYON·PARK
THIS · HISTORIC · AREA
AND·ITS·SVRROVNDINGS
WERE · DEVELOPED · AND
PRESENTED · TO · THE
PEOPLE·OF·THE·CITY·OF
NEW·YORK · IN ·1935· BY
JOHN·D·ROCKEFELLER·JR
THE·ADJACENT·HILLTOP
AN·OVTPOST·OF·FORT
WASHINGTON·WAS·GAL
LANTLY· DEFENDED · IN
NOVEMBER·1776·BY·THE
MARYLAND·AND·VIRGINIA
REGIMENT · · · AFTER·ITS
CAPTVRE·IT·WAS·NAMED
FORT·TRYON·IN·HONOR
OF·THE·LAST·ENGLISH·CIVIL
GOVERNOR·OF·NEW·YORK

This plaque honors John D. Rockefeller's contribution to the development of Fort Tryon Park and the heroism of the American soldiers who defended the site during the Battle of Fort Washington in November 1776. Fort Tryon was known as the Long Hill Fort to the Americans. During the British and Hessian occupation, it was renamed to honor the last royal governor of the province (or colony) of New York.

This plaque honors the George Washington bicentennial tree. The tree was planted in 1932 in Bennett Park on Fort Washington Avenue and 184th Street by the Washington Heights Memorial Honor Grove Association.

This plaque honors Pfc. Emilio Barbosa, who was killed on the USS *Nevada* when it was struck by a kamikaze. Barbosa, a native of Nicaragua, moved to Washington Heights with his family and joined the marines. He was the only member of the ship who came from the neighborhood.

Two

GEORGE WASHINGTON BRIDGE

For four generations, a familiar sight has graced the Hudson River connecting New York and New Jersey. The George Washington Bridge is a tribute of civil engineering to the people who conceived, built, and made the bridge what it is today.

Prior to the conception of the George Washington Bridge, there were numerous proposals for a bridge spanning the Hudson River. Between the years 1866 and 1927, six companies offered 18 different designs and five different locations were considered for construction.

In April 1921, Gov. George A. Silzer of New Jersey gave preliminary plans drawn by Othmar Ammann to the port authority for consideration. Four years later, New York and New Jersey passed legislation to construct, operate, and maintain a bridge across the Hudson River between 170th Street and 185th Street. By August 1926, Silzer and Gov. Al Smith had agreed on the location: 179th Street.

Othmar Ammann, the engineer of the George Washington Bridge, designed the bridge to be built in three stages. The first stage would connect New York and New Jersey for vehicular traffic. The second stage would be the completion of a lower level. The third and most important stage was to build a bridge that could handle the weight of an upper and lower level.

Groundbreaking ceremonies were held on September 27, 1927, and on October 25, 1931, the bridge was dedicated and opened to vehicular and pedestrian traffic. Some 55,000 cars traveled the span on opening day. However, with the completion of the bridge came traffic problems in Fort Lee and in Washington Heights, and highways had to be built to compensate for traffic in New Jersey.

Originally there were six lanes for traffic with a central area left undeveloped. In 1946, traffic had increased to the point where two additional lanes were constructed. Then on August 29, 1962, the lower level was added to allow for six additional lanes of vehicular traffic, thus increasing the capacity of the bridge by 75 percent and making it the world's first 14-lane suspension bridge.

Today the George Washington Bridge is the third-longest suspension bridge in the world. The bridge continues to play a dominant role, acting as a major route connecting New York and New Jersey with other parts of the Northeast and the rest of the country.

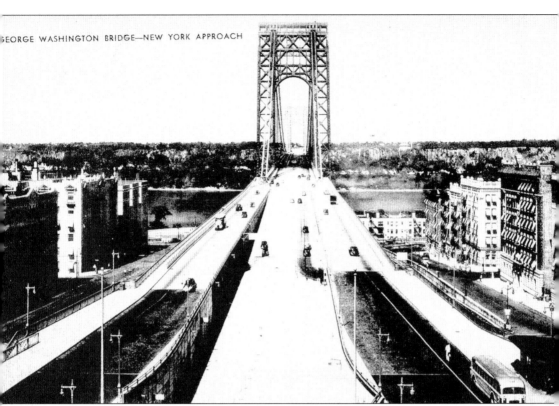

This image is a postcard of the Manhattan side of the George Washington Bridge during the 1930s. The bridge opened in October 1931, nine months ahead of schedule. It was to be encased in granite but because of the Depression was never done and the structure remained as it is. The bridge celebrated its 75th anniversary on October 25, 2006, with members of Othmar Ammann's family and the Swiss ambassador in attendance.

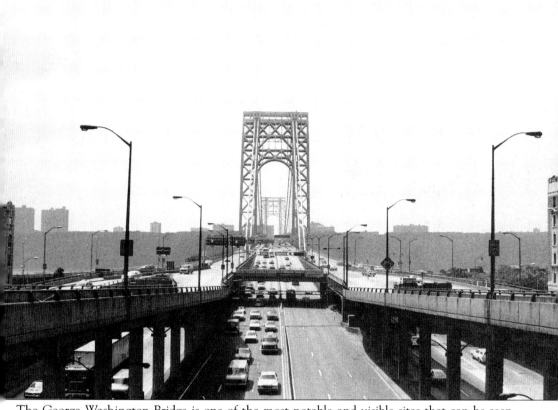

The George Washington Bridge is one of the most notable and visible sites that can be seen from Washington Heights. When it first opened in 1931, its purpose was to improve automotive traffic between New York and New Jersey. In the process, the ferryboats that plied the Hudson River with passengers and automobiles were eventually put out of business. Currently the bridge has 14 automotive lanes (8 on top and 6 on the lower level), and it serves as a major thoroughfare between New England and the rest of the country.

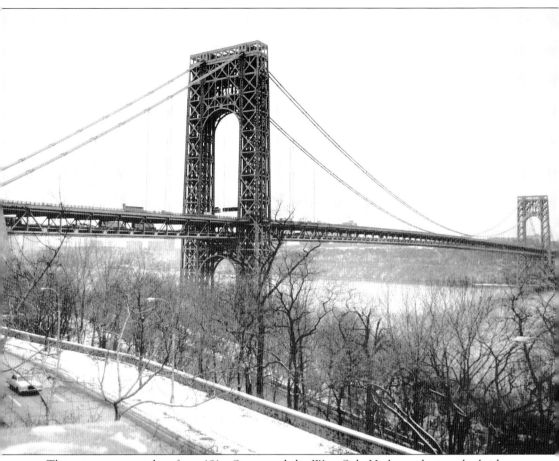

This winter scene taken from 181st Street and the West Side Highway depicts the bridge as an all-weather bridge.

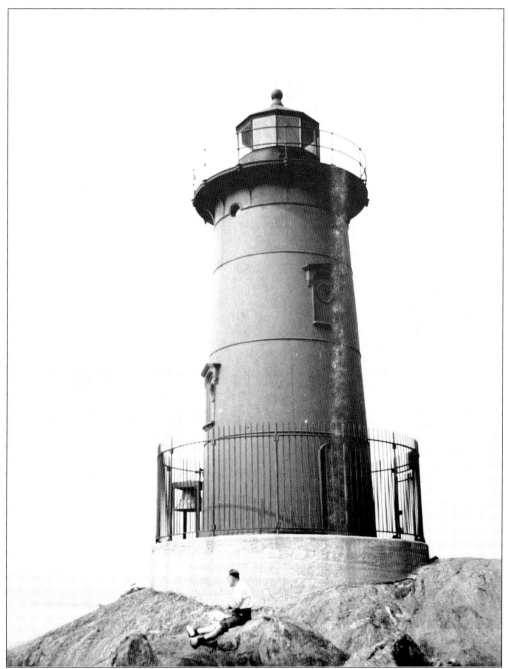

This particular photograph shows the Little Red Light House with its famous bell. Together with a signal, it was used until the late 1940s. The Fresnel lens that was used was powered by a 100-candlepower light that rotated every three seconds. Over the years, the lighthouse has been a favorite spot for the young and old to be by the shores of the Hudson River for picnics and fun or just to relax.

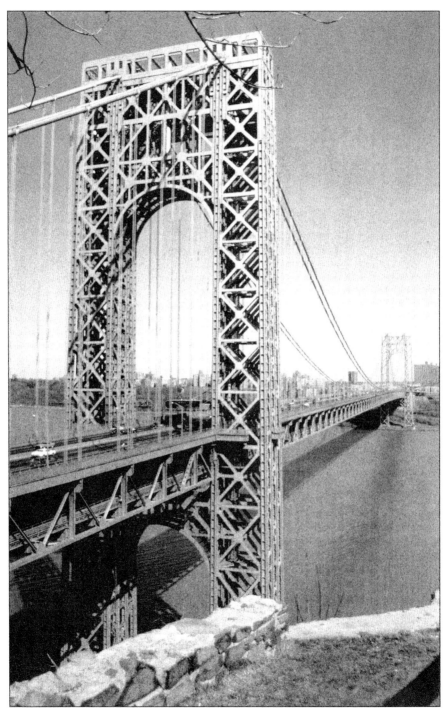

The George Washington Bridge is one of the most spectacular sites on the Hudson and a towering monument to man's genius. Construction began in 1927 and finished in 1931. It has inspired artists and photographers with its massive towers and lighted cables. In 1947, Charles Eduard Jenneret (Le Corbusier) wrote of the bridge in his book *When the Cathedrals were White*, "the most beautiful bridge, it is blessed; it is the only seat of grace in the disorderly city."

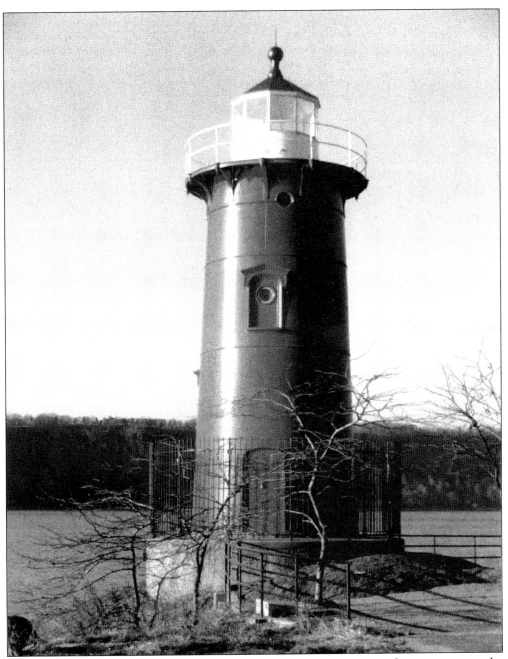

This photograph shows the Little Red Light House during its renovation. It is now open to the public on a regular basis, with the Urban Park Rangers giving tours and allowing people to go to the top. The light has been restored and can be seen at nighttime.

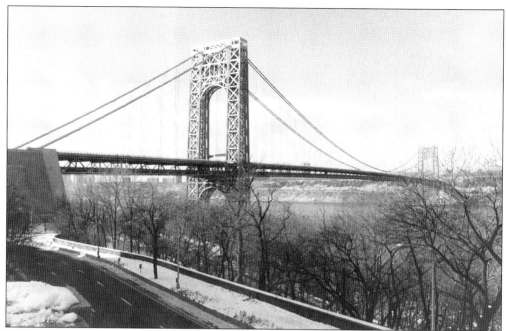

This is another view of the bridge during the winter from 181st Street and the West Side Highway.

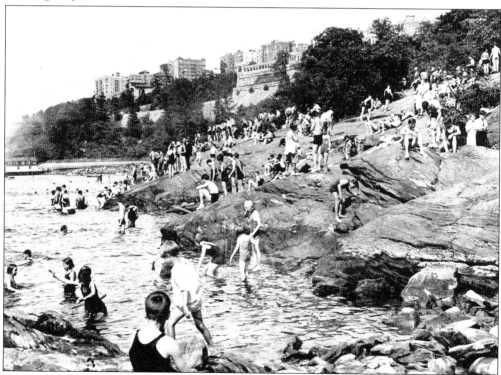

This photograph, taken in 1932, shows swimmers in the Hudson River near the Little Red Light House. Evidently it was a lot safer to swim in the river at that time. In the background is Castle Village where the Paterno estate was once located.

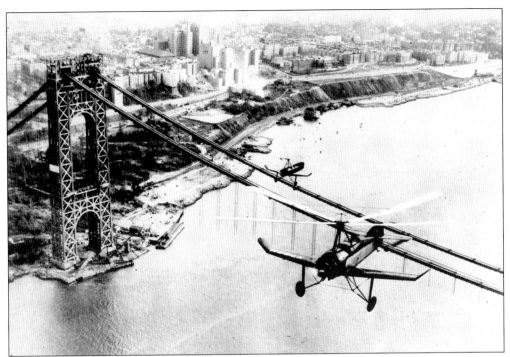

This 1929 aerial photograph shows the construction of the George Washington Bridge. The odd-looking aircraft are called autogiros, which are a combination of airplane and helicopter. They took off and landed like an airplane. It was this type of aircraft that led to the development of the present-day helicopters.

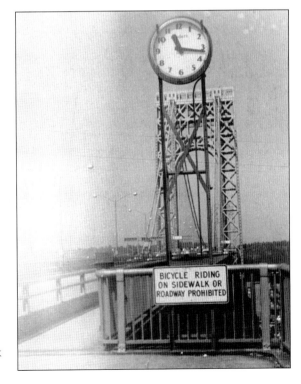

This clock told pedestrians the time of day it was when they walked on the north side of the George Washington Bridge. When the time came, the clock was taken down.

This 1933 photograph shows the Manhattan approach to the bridge with the Washington Arms building and the Young Men's-Young Women's Hebrew Association (formerly Fourth Church of Christ, a Methodist church). These buildings were there until the early 1960s, when they were demolished for the George Washington Bridge bus station.

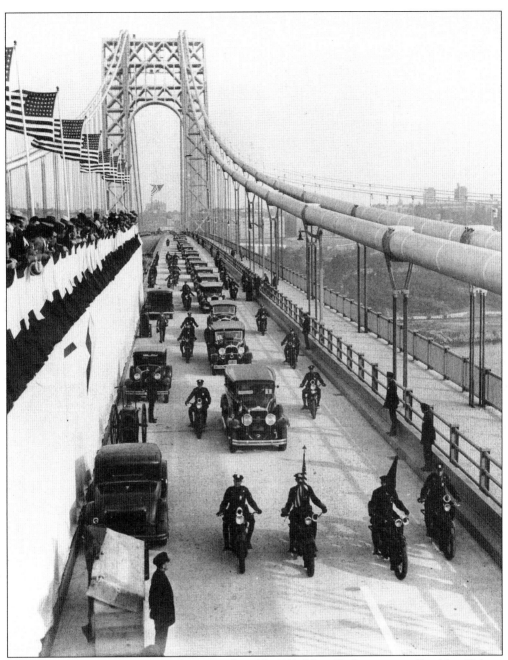

The bridge was officially opened on October 25, 1931. New York governor Franklin Delano Roosevelt came by motorcade to join with New Jersey governor Harold Moore for the ceremonies. The bridge celebrated its 75th anniversary on October 25, 2006, at the Fort Lee Historic Park. The family of Othmar Ammann, a member of the Swiss consulate, and members of the Port Authority of New York and New Jersey were in attendance.

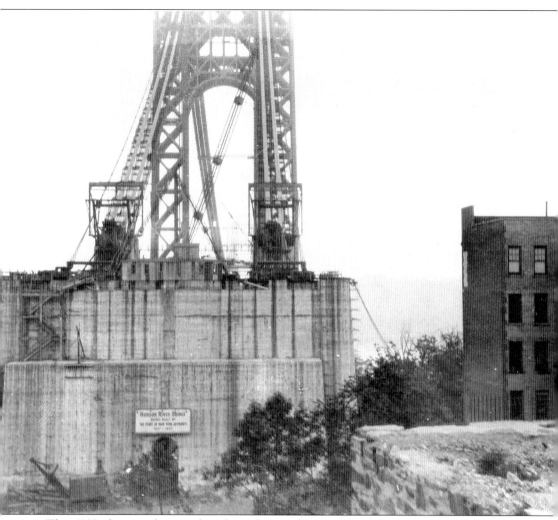

This 1929 photograph was taken from the Manhattan side of the bridge. There is a sign that says, "Hudson River Bridge being built by the Port of New York Authority 1927–1932."

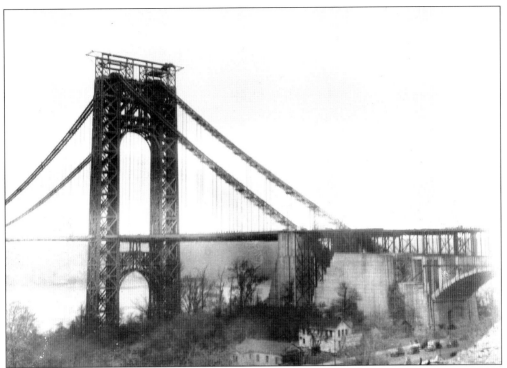

This 1930 view from the southeast shows the bridge being built with the roadway being laid out.

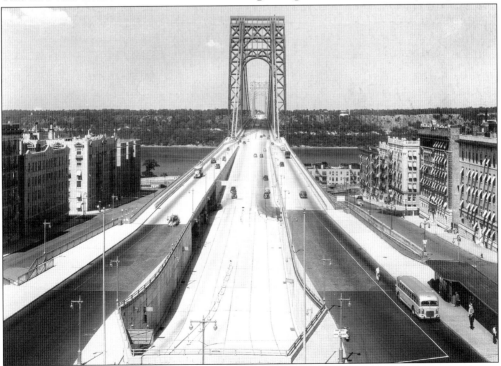

This 1935 photograph shows the bridge approach with New Jersey and the Palisades in the background.

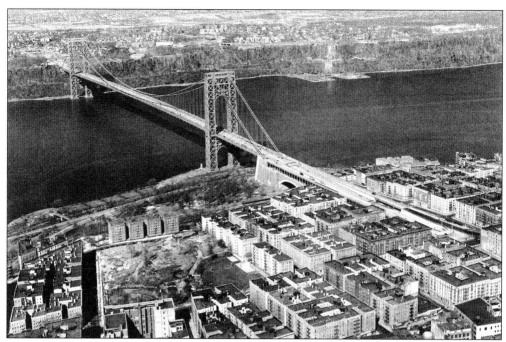

This 1957 photograph shows in detail the area near the George Washington Bridge in Manhattan and the New Jersey Palisades in the background.

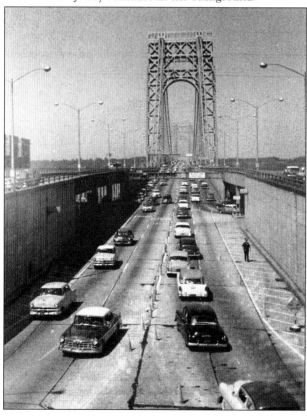

This 1957 photograph shows cars entering and leaving the bridge.

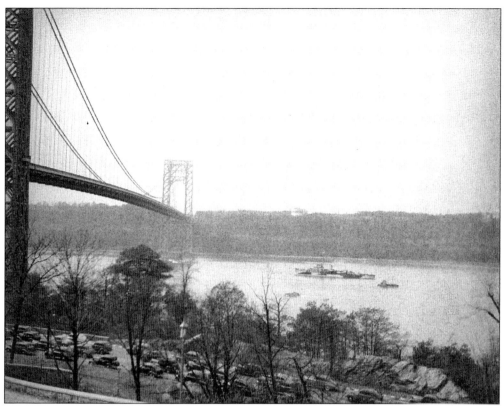

The bridge is shown here in 1942. In the Hudson River is a navy frigate. There is automotive traffic on the Henry Hudson Parkway.

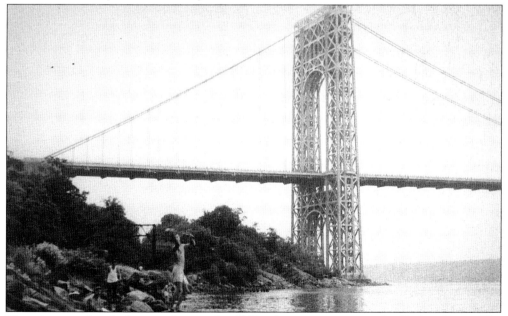

This photograph, which was taken in the 1940s, shows swimmers in the Hudson River. The George Washington Bridge is in the background.

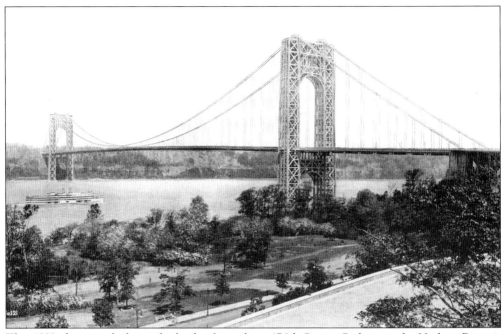

This 1939 photograph shows the bridge from about 176th Street. Sailing up the Hudson River is the *Dayliner* to West Point.

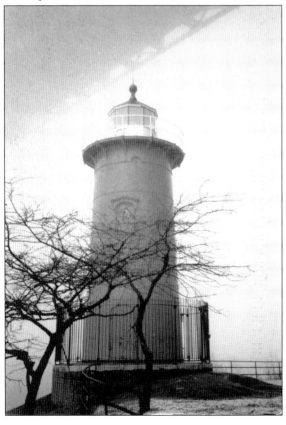

Seen here is one of the various photographs of the Little Red Light House.

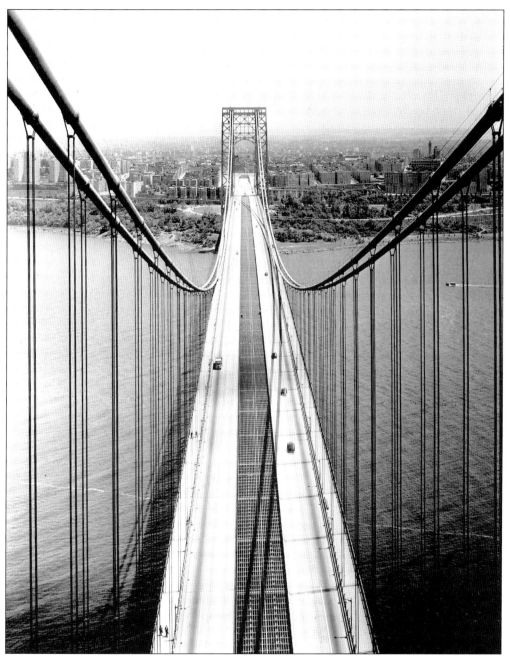

This 1942 photograph was taken from the New Jersey tower looking toward Manhattan. The main deck is a six-lane highway with two pedestrian walkways on either side. After World War II, two additional lanes were added in the center of the bridge to allow for more traffic.

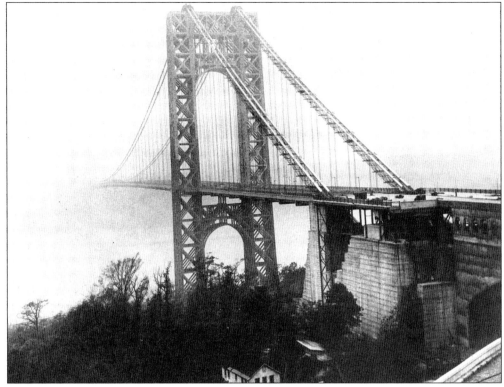

The George Washington Bridge is shown under construction in 1930. Note the construction equipment on the deck of the bridge and the houses in the park at the base of the bridge.

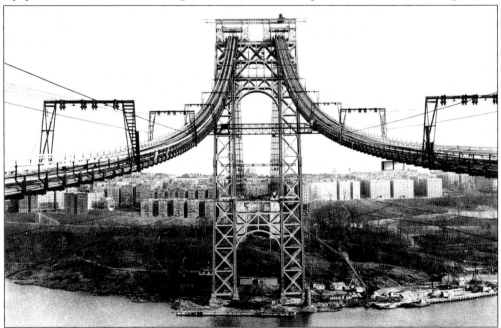

This photograph shows the detail of the bridge's walkways, which were prepared to be spun for cables. This 1929 photograph also shows the Manhattan tower.

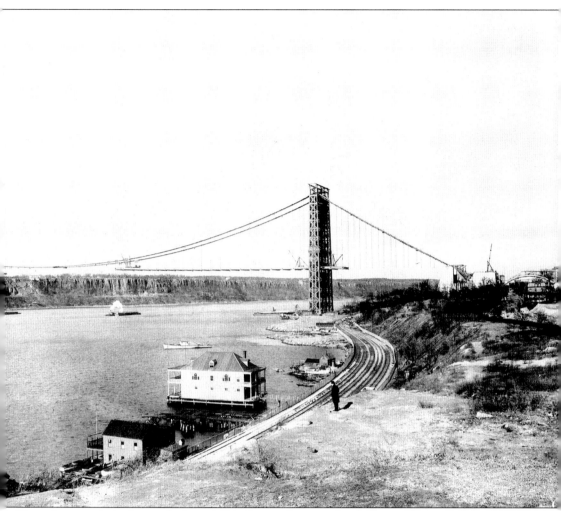

This photograph looks north from 165th Street showing the bridge under construction in the background. In the foreground are the various boating clubs that dotted the Hudson and Harlem Rivers.

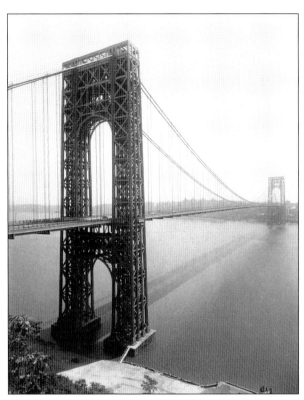

Pictured here is a view of the George Washington Bridge from Fort Lee, New Jersey.

This 1935 image shows the painting of the towers of the George Washington Bridge in Manhattan.

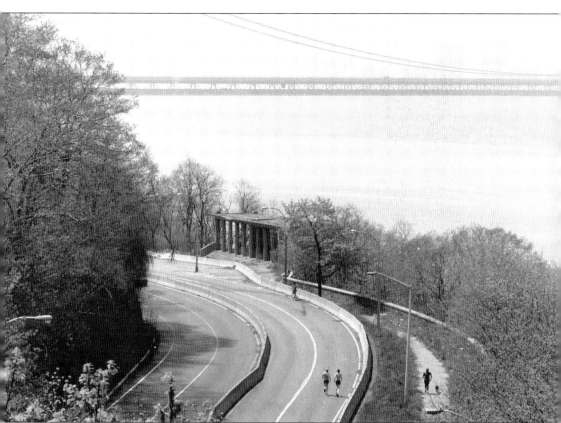

The gazebo at Inspiration Point had undergone extensive renovation at the time this photograph was taken. It got its name, Inspiration Point, because of the fantastic views of the Hudson River.

This photograph was taken just after the renovation of the Little Red Light House.

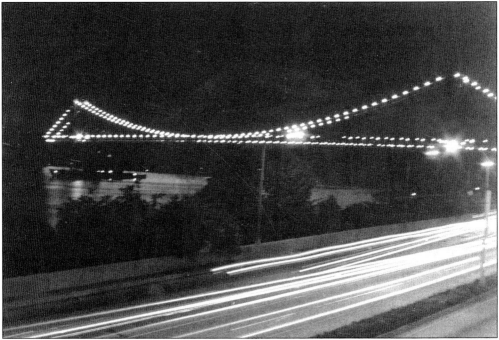

The George Washington Bridge is seen here at night during the bicentennial celebrations in New York City on July 4, 1976. Note the outline of the ship from the reflection of light on the water. (Author's collection.)

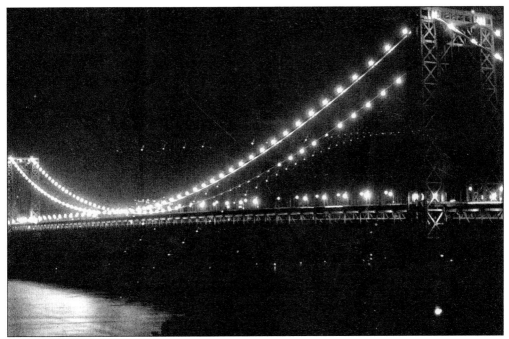

Seen here is another photograph of the George Washington Bridge taken during the bicentennial celebration in New York City. (Author's collection.)

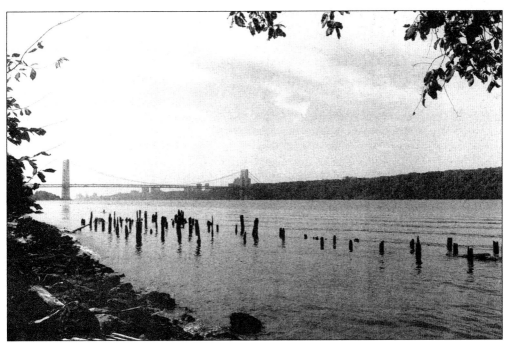

This particular photograph of the George Washington Bridge was taken at Dyckman Street and the Hudson River. (Author's collection.)

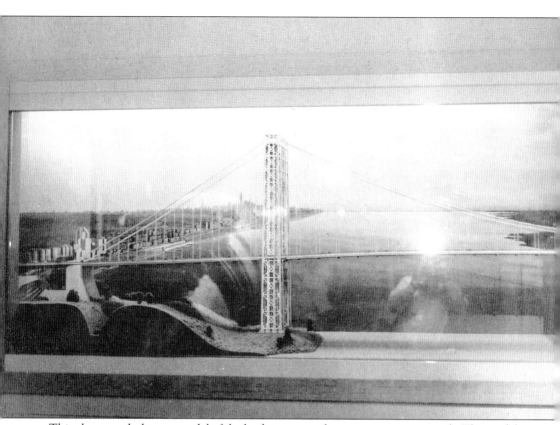

This photograph shows a model of the bridge as part of a new engineering epoch. The model is on display at the Smithsonian Institution's Museum of American History. (Author's collection.)

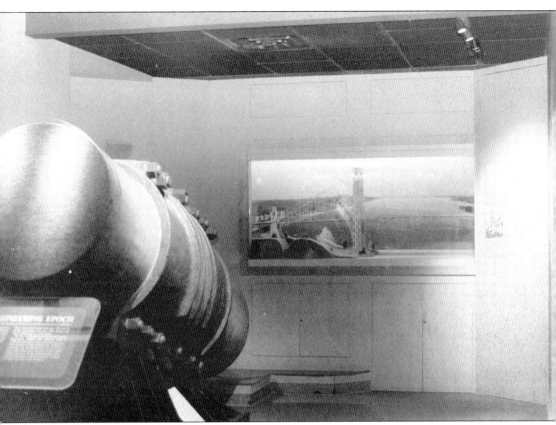

This photograph shows the test cable of the bridge to demonstrate what the cross section of the cable looks like before it is actually spun on site at the bridge. (Author's collection.)

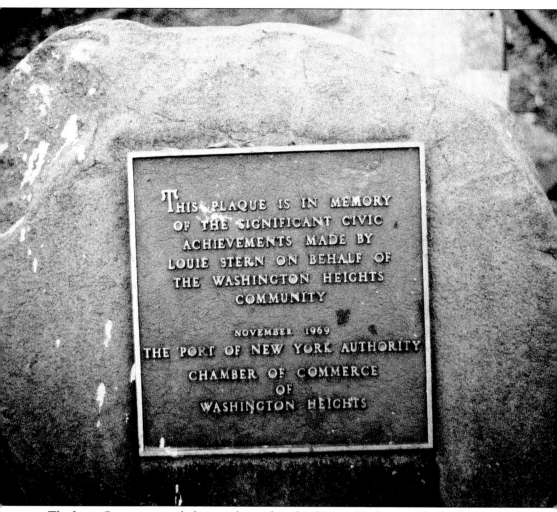

THIS PLAQUE IS IN MEMORY
OF THE SIGNIFICANT CIVIC
ACHIEVEMENTS MADE BY
LOUIE STERN ON BEHALF OF
THE WASHINGTON HEIGHTS
COMMUNITY

NOVEMBER 1969
THE PORT OF NEW YORK AUTHORITY

CHAMBER OF COMMERCE
OF
WASHINGTON HEIGHTS

The Louis Stern memorial plaque is located in the George Washington Bridge Park on Cabrini Boulevard between 177th and 178th Streets. It was placed there by the Port of New York Authority and the Chamber of Commerce of Washington Heights for Stern's contributions to the community. The Port of New York Authority is now the Port Authority of New York and New Jersey.

Three

INWOOD AND
MARBLE HILL

Inwood was originally inhabited by the Lenape Confederacy. In the early part of the 20th century, Native American artifacts and grave sites were excavated by Reginald Pelham Bolton and William Calvert, showing the many sites of early inhabitation. The Indian Caves of Inwood Hill Park are also testimony to this cultural group.

During the Dutch Colonial period, Inwood was settled by two of the patentees of the village of Nieuw Haarlem, Jan Dyckman and Jan Nagel. Both realized that eventually there would be a mass migration to northern Manhattan, and they planned the village to meet the future population demands.

The Marble Hill community in the Bronx is the only part of Manhattan connected to the mainland due to a little-known quirk of geography. Originally, this 42-acre enclave was the northernmost section of the borough of Manhattan and was surrounded by the winding Spuyten Duyvil Creek. In 1895, the course of the creek was changed to improve navigation around Manhattan, thus physically separating Marble Hill from Manhattan. For 19 years it remained as an artificial island until the ground that was removed to make way for the new course of the creek was used as landfill for the former course of the stream.

The name of Marble Hill was conceived by Darius C. Crosby in 1891 from the local deposits of dolomite marble, a relatively soft rock that overlay the Inwood and Marble Hill communities. The marble was quarried for the federal buildings in Lower Manhattan when New York was the capital of the United States in the 1780s.

Marble Hill's borders have always been a bit controversial, and on March 11, 1939, Bronx borough president James J. Lyons planted the Bronx County flag on the rocky promontory at 225th Street and Jacobus Place proclaiming Marble Hill as a part of the Bronx and demanding the subservience of its residents to the Bronx. The response to the incident was met with an uproar by residents of Marble Hill. Residents refused to change their status and wanted to remain loyal residents of Manhattan. Petitions and signatures were gathered to be sent to Gov. Herbert Lehman to ensure Marble Hill remained part of Manhattan.

Even though it is the landlocked part of Manhattan, Marble Hill still shares the privileges enjoyed by the borough. And recently there has been a massive immigration of artists, musicians, actors, and families to both communities looking for less expensive neighborhoods to live in.

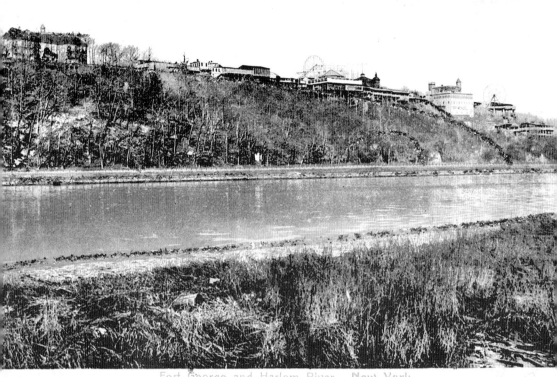

Fort George and Harlem River. New York.

This amusement park, located on what is now Amsterdam Avenue between 190th and 192nd Streets, was a major source of entertainment between 1895 and 1914. One of its customers was Marcus Loew, who eventually started the Loew's Theater Group. The park burned down in 1914.

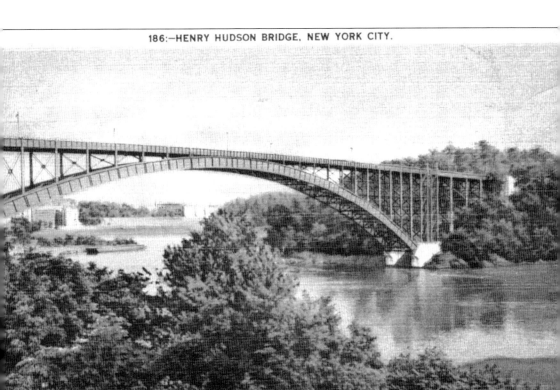

The original design of the bridge was for the Hudson-Fulton celebration in 1909. The present structure was officially opened December 12, 1936, under the Robert Moses administration. At the time it was the largest plate-girder fixed-arch bridge in the United States. It had a four-lane highway with pedestrian walkways on either side. The lower level was originally intended for railroad tracks but was scrapped, and a new highway was put in its place.

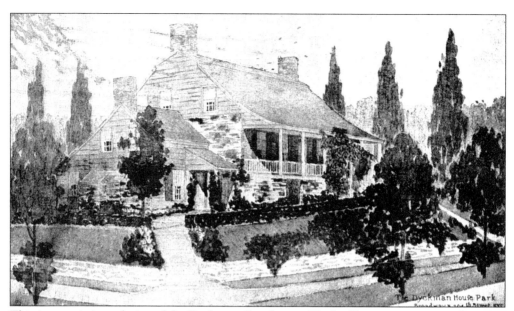

This is an artist's rendering of the Dyckman Farmhouse. The building was constructed in 1784 after the American Revolution when the Dyckman family left its land for Westchester. The land was occupied by the Hessians, who had burned the original house before the end of the war.

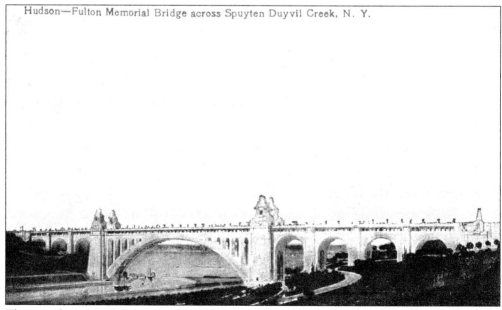

This was the original design for the bridge that was to become the Henry Hudson Bridge built by Robert Moses. It was supposed to be built in 1909 as a result of the Hudson-Fulton celebration commemorating the sailing up the Hudson River of Henry Hudson in the *Half Moon* in 1609 and of Robert Fulton's trip in 1807 with the *Clermont*.

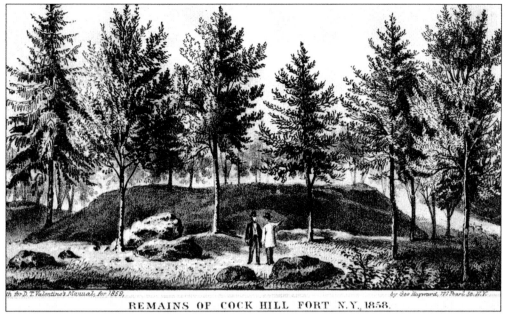

REMAINS OF COCK HILL FORT N.Y., 1858.

The Cock Hill Fort in what is now Inwood Hill Park was a northern defensive outpost of Fort Washington, which is located in Bennett Park on 183rd Street and Fort Washington Avenue. The Cock Hill Fort was a cannon emplacement providing firepower to the north and east. This earthworks fort was abandoned after the fall of Fort Washington. This is a D. T. Valentine card. (Author's collection.)

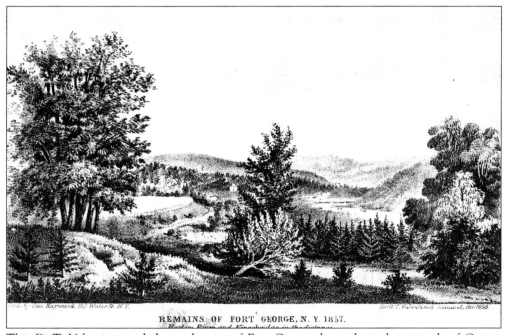

REMAINS OF FORT GEORGE, N. Y. 1857.

This D. T. Valentine card shows the site of Fort George, located on the grounds of George Washington High School at 192nd Street and Amsterdam Avenue. This earthworks fortification was taken over by the British and Hessians and named for King George III. (Author's collection.)

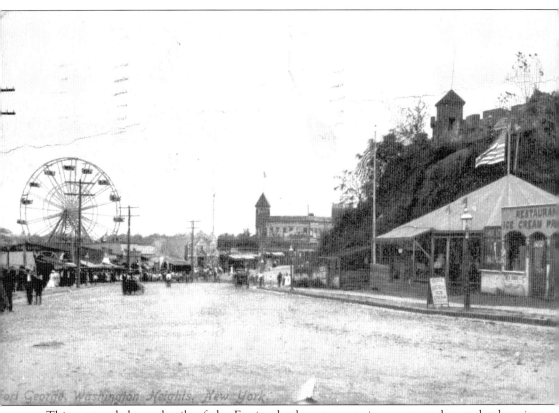

Fort George, Washington Heights, New York.

This postcard shows details of the Ferris wheel, restaurant, ice-cream parlor, and other sites of the Fort George Amusement Park that visitors could go to. The park was accessible by the Third Avenue Trolley Company, and electrical power was provided by the nearby Westinghouse power plant, which was later taken over by Con Edison. Fort George Amusement Park was in operation from 1895 until 1914. After the park was destroyed in 1914, it was absorbed into Highbridge Park.

The Dyckman Farmhouse was built in 1784 as a result of the original Dyckman home being burned by the Hessians during the American Revolution. William Dyckman, the grandson of Jan Dyckman, lived in the house prior to the outbreak of hostilities. Jan Dyckman settled the property in the 1660s with Jan Nagel. This clapboard house served three generations of the family until 1868. It is the only Dutch farmhouse in Manhattan. Today there is a reconstructed Hessian officer's hut built in 1915 to represent how the Hessians lived.

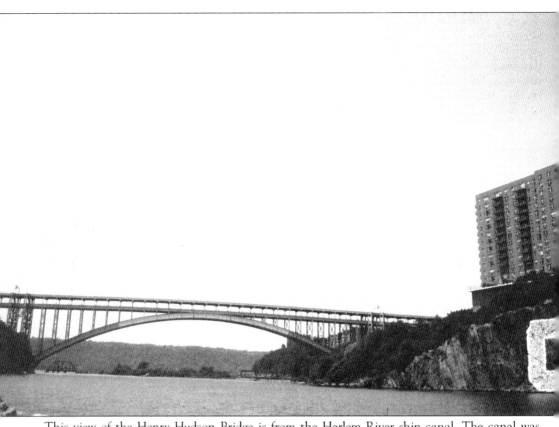

This view of the Henry Hudson Bridge is from the Harlem River ship canal. The canal was originally known as the Spuyten Duyvil Creek, which had a different route. It went from the Harlem River north to 231st Street in the Bronx then west, turned south, then west again. It was rerouted and dredged to allow for an improved shipping lane. In the 1950s, a Columbia University medical student painted a C on the face of a rock outcropping near Columbia's Baker Field.

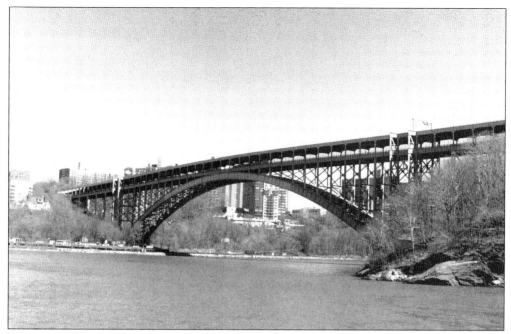

This view of the bridge is from the Hudson River showing the entrance to the Harlem River ship canal from the Spuyten Duyvil Railroad trestle. Under the bridge on the Bronx side is the Spuyten Duyvil train station.

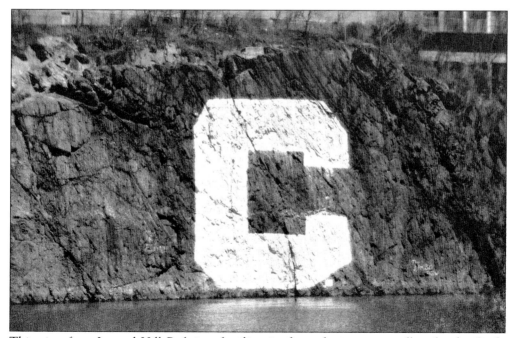

This view from Inwood Hill Park is a familiar site for park visitors as well as for the Circle Line sightseeing boats. The C was started in the early 1950s by a Columbia University medical student and is still maintained by the Columbia staff and students annually.

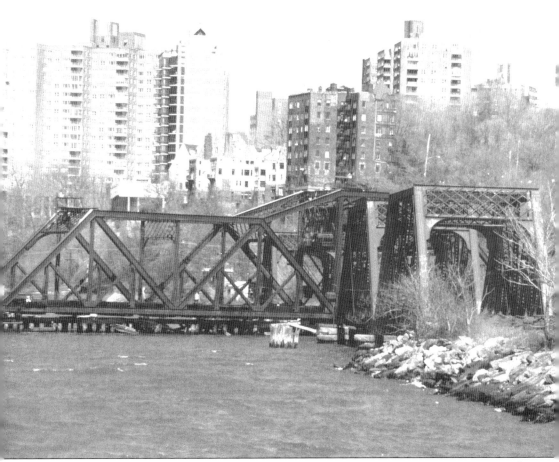

This trestle was constructed to connect Manhattan with the mainland (the Bronx) to allow railroad traffic to Albany. The New York and Hudson River Railroad Company was organized in 1847 for passenger and cargo traffic along the Hudson River, especially during the winter months when the river froze. Two years later the first tracks were laid from New York City to Peekskill with a wooden trestle and bridge at Spuyten Duyvil. It was replaced with a steel structure in 1899. In 1862, Cornelius Vanderbilt bought stocks of the New York and Hudson River Railroad and the New York and Harlem River Railroad and renamed it the New York Central Railroad.

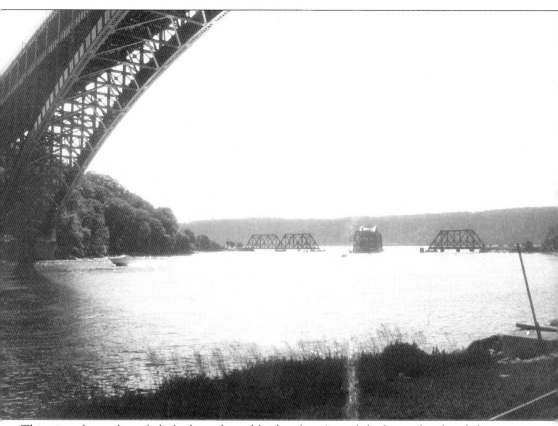

This view shows the refurbished trestle and bridge that Amtrak had completed and that was reopened in 1991 after a period where the bridge was left in the open position. A Circle Line boat accidentally hit the bridge in 1983. Currently there is someone manning the bridge so that all boat traffic can pass easily and without hindrance.

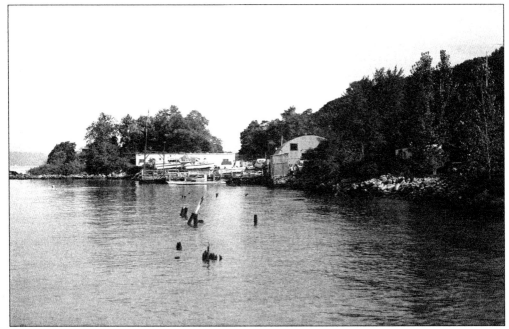

The Dyckman Street Marina is the former Dyckman Street Ferry Landing where ferryboats traveled from Englewood, New Jersey, to New York. It became a marina in the 1950s when the ferryboats were put out of service by automotive traffic going over the George Washington Bridge. Buses going over the bridge had taken away the passengers from the ferry.

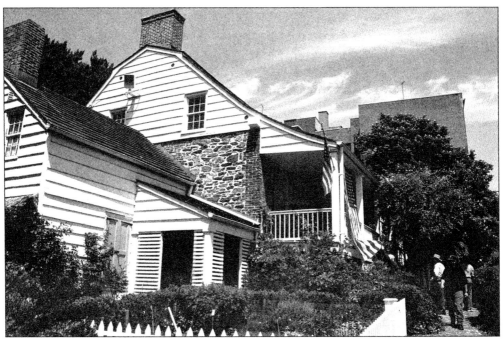

This is a view of the Dyckman Farmhouse Museum built in 1785 with a tour group arriving to see the house.

This 1861 lithograph shows the home of two of the settlers of northern Manhattan, Jan Nagel and Tobias Teunissen. Nagel acquired the property in 1677 and formed a partnership with Jan Dyckman to purchase land in the area. Both had realized the real estate value of the area, knowing of a future migration to the area over the next few centuries.

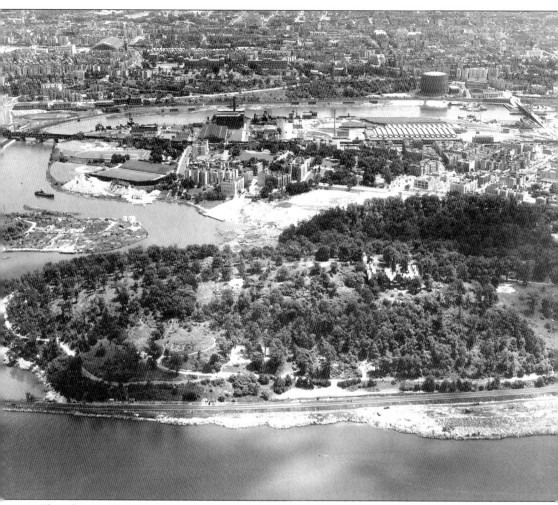

This photograph, which was taken over the Hudson River looking east, shows Inwood Hill Park in the foreground. At the time there were parts of the park that housed private institutions. The Spuyten Duyvil Creek was yet to be developed and shows the inlet where the Johnson Ironworks Foundry was located. Inwood itself has been developed, and the 207th Street subway yards can be seen, as can the Broadway Bridge, which goes from 220th Street in Manhattan to 225th Street in Marble Hill. The railroad tracks on the Hudson River were for passenger and freight trains traveling to and from points along the Hudson River.

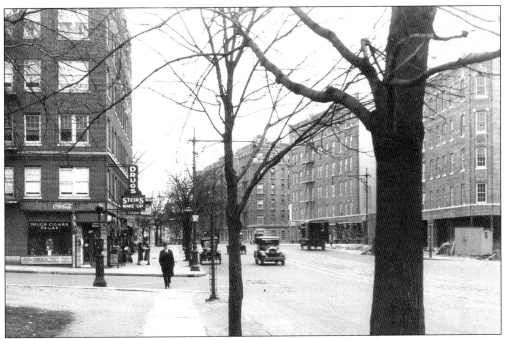

This photograph shows a northerly view of Broadway at the corner of Isham Street in 1925. One can note the Ford Model Ts that were commonly used during this time. Also the Stein's Drug Store was one of the many shops in the area.

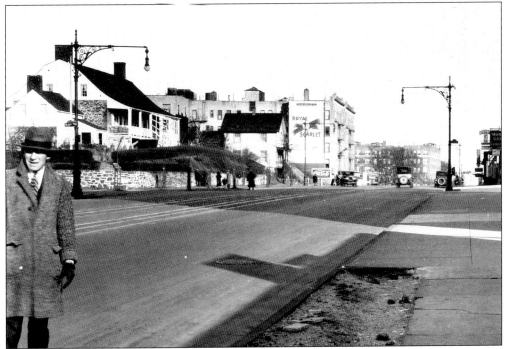

This 1925 photograph shows the Dyckman Farmhouse Museum on the left in the background, showing Broadway northbound from 204th Street. Take note of the Royal Scarlet Cocoa advertisement and the Coca-Cola advertisement on the side of the building in the background.

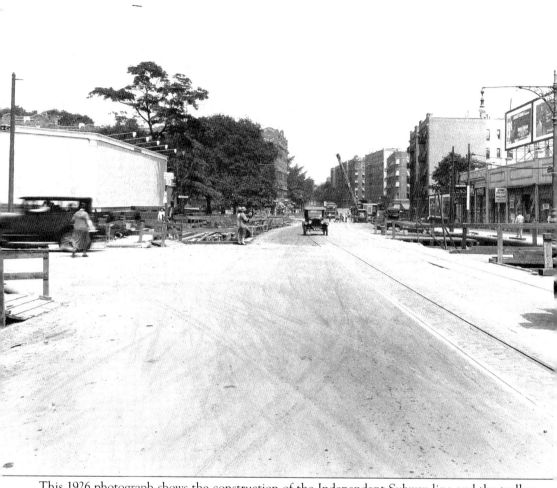

This 1926 photograph shows the construction of the Independent Subway line and the trolley lines that are used for mass transportation. Billboard advertising on top of the building on the right was important at the time to assist in sales to the community and to the stores that were open at the time.

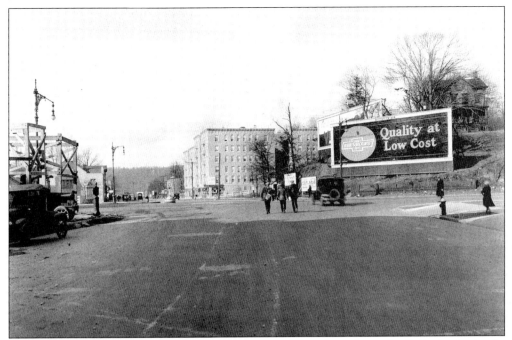

This 1926 view of Dyckman Street going west toward Broadway shows the Palisades in the far background. This was probably taken from Vermilyea Avenue. One can barely note the traffic signal on Broadway and the construction on the left.

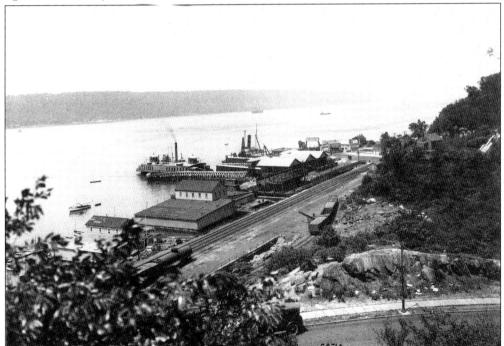

The Dyckman Street ferry plied the Hudson River to Englewood, New Jersey, between 1915 and 1942. The landing was also used as a marina for residents like C. K. G. Billings. The demise of the ferry was due to the traffic on the George Washington Bridge.

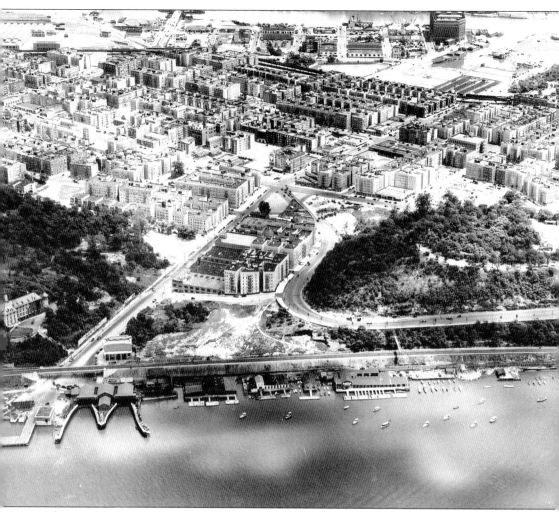

This 1935 photograph shows what is now known as the Tubby Hook section of Inwood. Along the Hudson are the Dyckman Street Ferry Terminal, the Dyckman Street Marina, and many of the boating clubs that have since gone out of business. Also shown is the Dyckman Street railroad station of the New York and Hudson River Railroad. On the East River is the Con Edison Plant and Sherman Creek with boating clubs there. In the upper left-hand corner is the 207th Street subway yard.

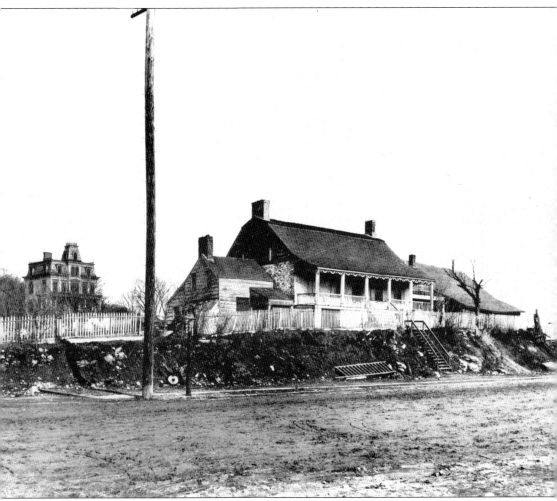

This 1895 photograph depicts the farmhouse in an urban setting. Several things are of note; for example, Broadway is a dirt road and the pole that has electrical wires above ground. When the building was turned over to the parks department, the part of the house to the right of the front porch was razed to make way for parkland. The Victorian house in the background was another resident of Inwood.

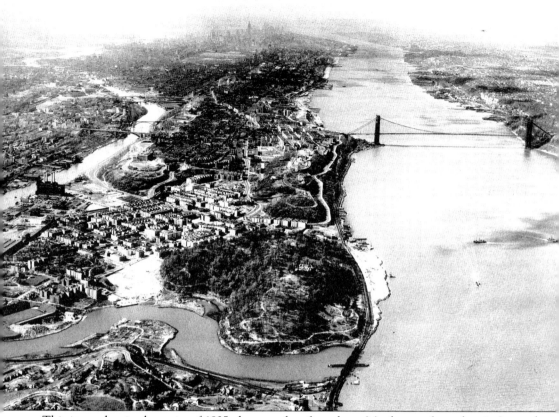

This is another in the series of 1935 photographs of northern Manhattan from the air. Inwood Hill Park is in the foreground with the Spuyten Duyvil Creek. As one looks farther to the background there is the George Washington Bridge on the Hudson River. The Washington Bridge and the Highbridge Aqueduct can be seen on the Harlem River.

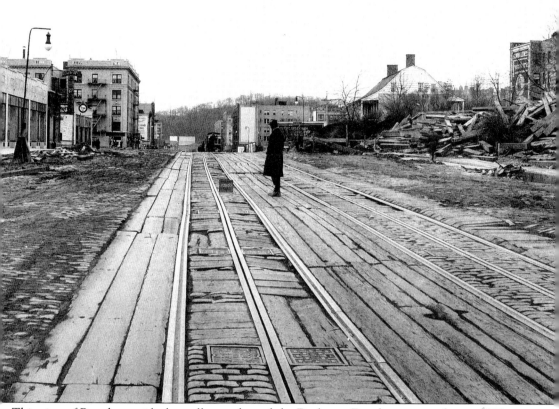

This view of Broadway with the trolley tracks and the Dyckman Farmhouse was taken in 1928. There seems to be a lot of construction of new housing in the area. In the far background is the wooded area that will become Fort Tryon Park.

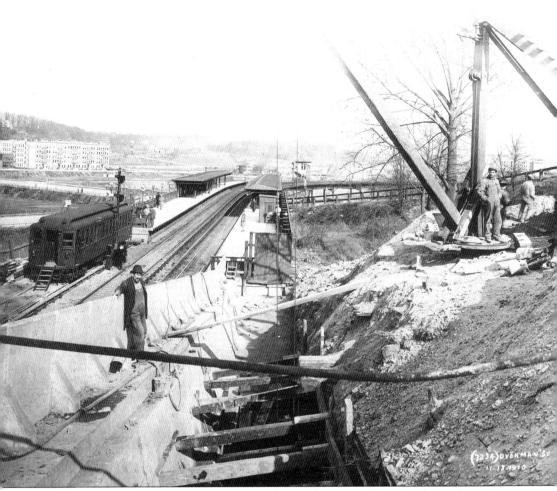

This 1910 photograph shows the Interborough Rapid Transit Subway Dyckman Street Station as it goes from underground to elevated and then along Tenth Avenue. There is also construction in progress. In the background are apartment buildings that are rented to residents.

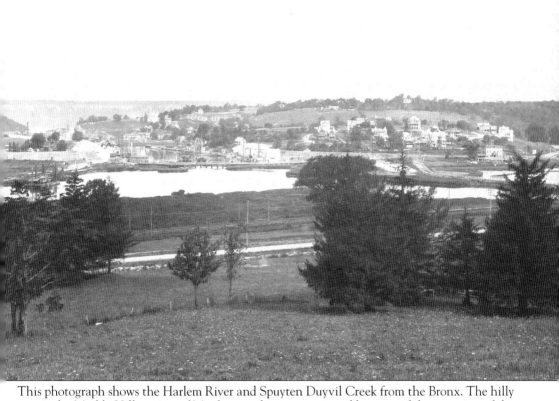

This photograph shows the Harlem River and Spuyten Duyvil Creek from the Bronx. The hilly area is the Marble Hill section of Manhattan that was separated because of the rerouting of the river for better navigation around Manhattan.

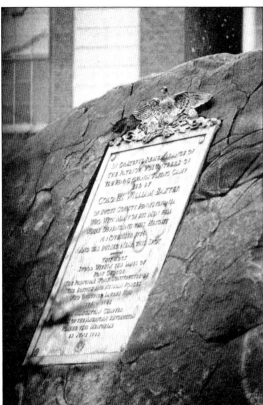

Fort Clearview was the name of the American fort that was overrun by the Hessians and renamed Fort George after the surrender of Fort Washington. George Washington High School is now on the site of Fort George.

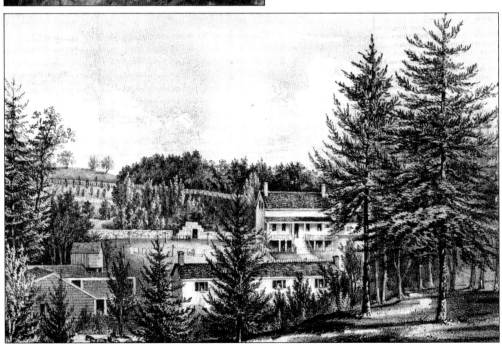

This 1861 lithograph shows the residence and estate of Isaac Dyckman. It also shows the other houses that are a part of the estate.

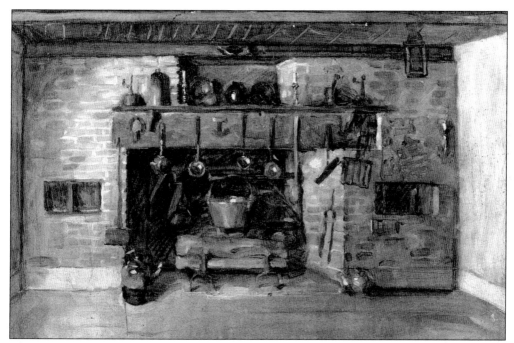

This is a painting of the fireplace in the main kitchen of the Dyckman Farmhouse Museum, showing what was used and needed to make meals.

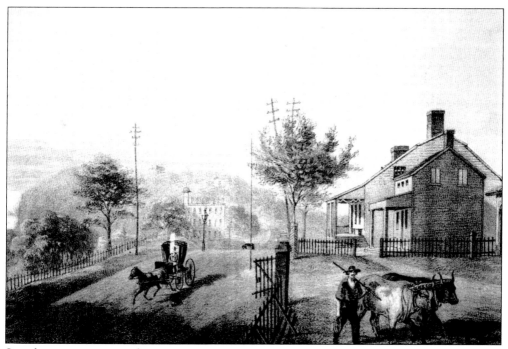

Seen here is a painting of a street scene in and around the Dyckman Farmhouse in the 1860s.

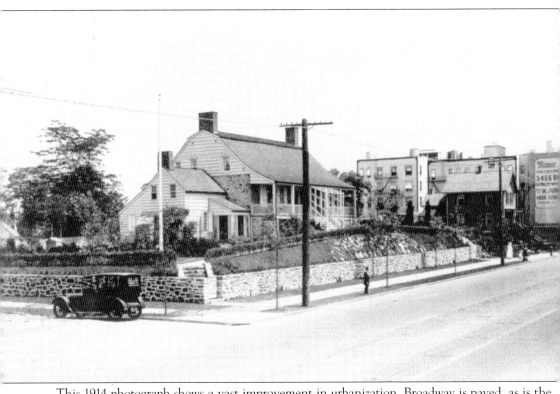

This 1914 photograph shows a vast improvement in urbanization. Broadway is paved, as is the pedestrian walkway in front of the Dyckman Farmhouse.

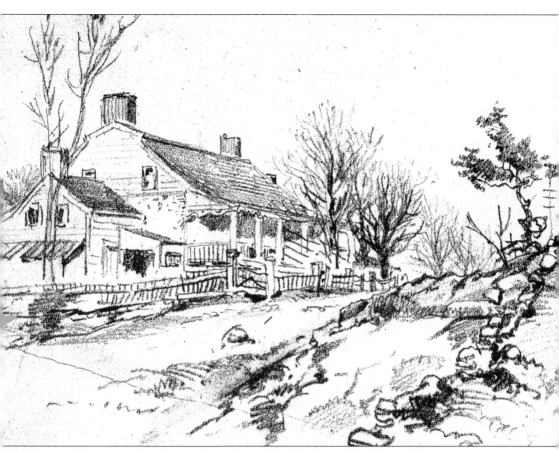

This is one of the many drawings and paintings of the Dyckman Farmhouse Museum.

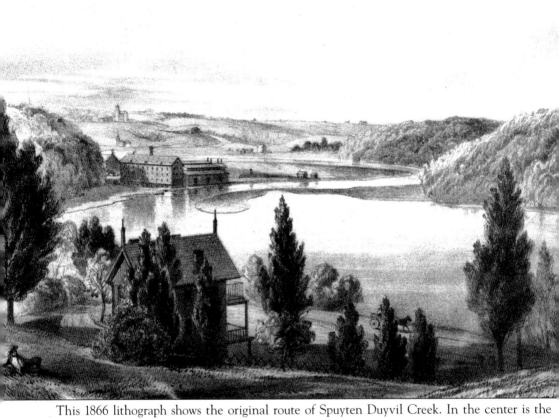

This 1866 lithograph shows the original route of Spuyten Duyvil Creek. In the center is the Johnson Ironworks Foundry, which made everything from die casts to locomotive engines. The company had even created specific jobs for the United States government, especially during the Civil War.

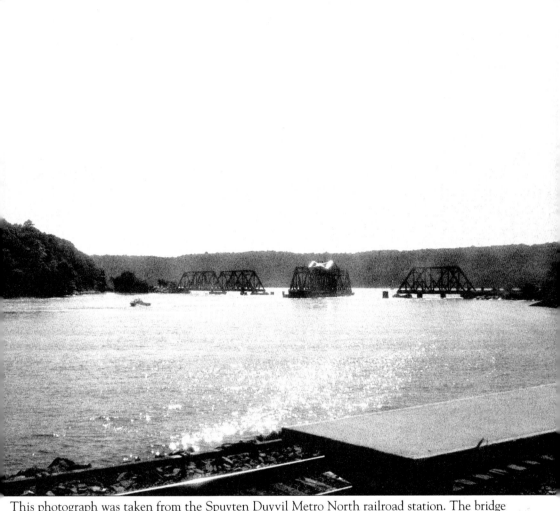

This photograph was taken from the Spuyten Duyvil Metro North railroad station. The bridge is in the open position to allow for boat traffic.

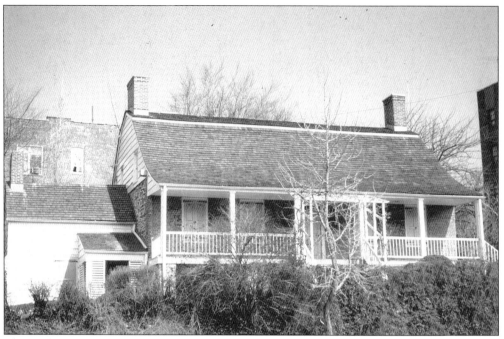

The Dyckman Farmhouse is pictured here as it looks today.

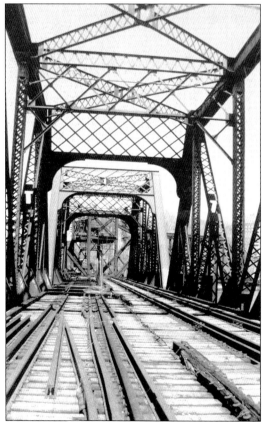

This photograph was taken on the Spuyten Duyvil Railroad Trestle as the train operators see it.

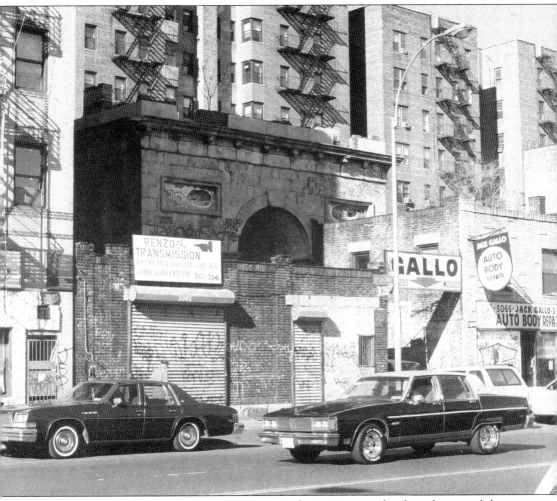

The Seaman-Drake Arch was the entrance to an estate for two separate families who owned the same property at different times of the 19th century, the Seamans and the Drakes. After the property was sold, the archway remained and an automotive shop was built around it.

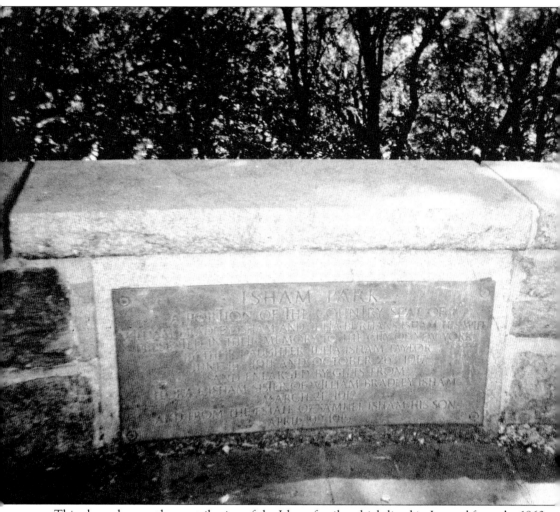

This plaque honors the contribution of the Isham family, which lived in Inwood from the 1860s to the beginning of the 20th century. The Isham children donated land to the park between 1912 and 1917.

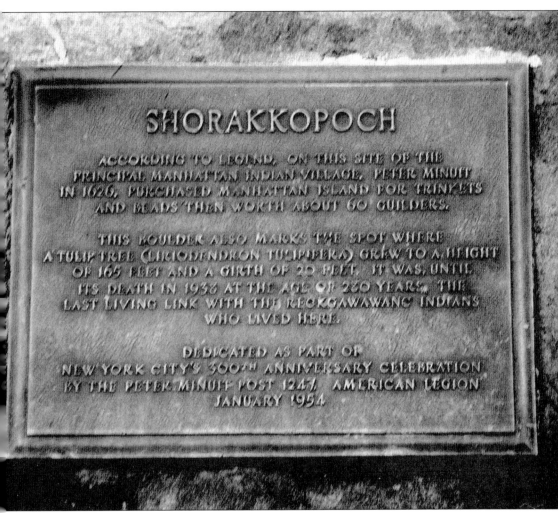

SHORAKKOPOCH

ACCORDING TO LEGEND, ON THIS SITE OF THE
PRINCIPAL MANHATTAN INDIAN VILLAGE, PETER MINUIT
IN 1626, PURCHASED MANHATTAN ISLAND FOR TRINKETS
AND BEADS THEN WORTH ABOUT 60 GUILDERS.

THIS BOULDER ALSO MARKS THE SPOT WHERE
A TULIP TREE (LIRIODENDRON TULIPIFERA) GREW TO A HEIGHT
OF 165 FEET AND A GIRTH OF 20 FEET. IT WAS, UNTIL
ITS DEATH IN 1938 AT THE AGE OF 280 YEARS, THE
LAST LIVING LINK WITH THE RECKGAWAWANC INDIANS
WHO LIVED HERE.

DEDICATED AS PART OF
NEW YORK CITY'S 300TH ANNIVERSARY CELEBRATION
BY THE PETER MINUIT POST 1247, AMERICAN LEGION
JANUARY 1954

This plaque was placed by the Peter Minuit American Legion Post in Inwood Hill Park in January 1954 to honor the legendary sale of New York to the Dutch by the Native Americans. A tulip tree was planted and stood there for 280 years. The tree died in 1938.

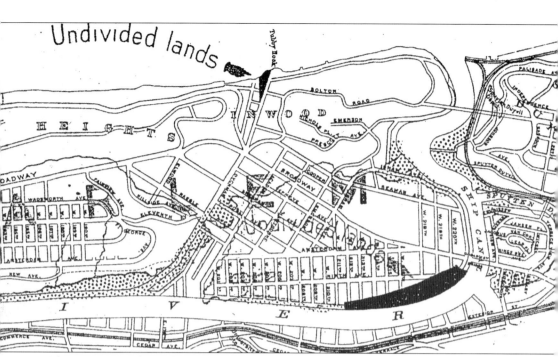

This 1900 map shows how different the street layout of Washington Heights, Inwood, and Marble Hill was as compared to today. The Spuyten Duyvil Creek still wraps around Marble Hill and will soon be filled in to attach the community to the Bronx. The ship canal will take the place of the creek because of the War Department's (now Department of Defense) edict to make the rivers around Manhattan more navigable.

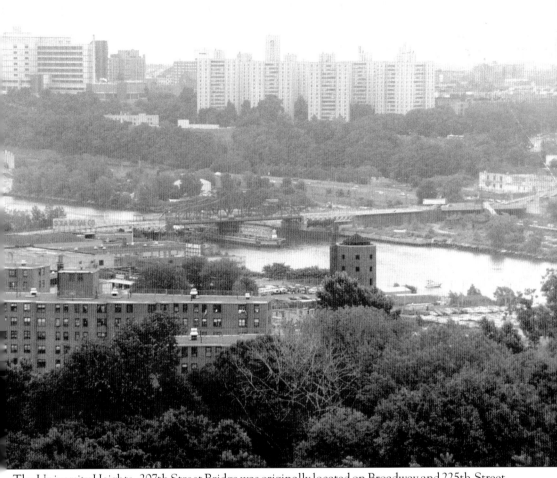

The University Heights–207th Street Bridge was originally located on Broadway and 225th Street, connecting Manhattan with Marble Hill. The bridge was dismantled and floated down the Harlem River to its present site when a new bridge was constructed in its place that could handle automotive and subway traffic.

ACROSS AMERICA, PEOPLE ARE DISCOVERING SOMETHING WONDERFUL. THEIR HERITAGE.

Arcadia Publishing is the leading local history publisher in the United States. With more than 3,000 titles in print and hundreds of new titles released every year, Arcadia has extensive specialized experience chronicling the history of communities and celebrating America's hidden stories, bringing to life the people, places, and events from the past. To discover the history of other communities across the nation, please visit:

www.arcadiapublishing.com

Customized search tools allow you to find regional history books about the town where you grew up, the cities where your friends and family live, the town where your parents met, or even that retirement spot you've been dreaming about.